HEAVY LIGHT

A JOURNEY OF TRANSFORMATION
THROUGH THE ART OF

Selected Images from 1962-1991

PART ONE: RESEARCH 1962-1971
PART TWO: FORMULA 1971-1980
PART THREE: TRANSFORMATION 1980-1990
PART FOUR: PLANETARIAN SCULPTURES 1987-1991

Published
by
MORPHEUS INTERNATIONAL
Fine Art of the Surreal, Fantastique & Macabre
200 N. Robertson Blvd., Suite #326
Beverly Hills, CA 90211 USA
(310) 859-2557

Correspondence:
P.O. Box 7246
Beverly Hills, CA 90212

First Edition: October 1993

Trade Paperback ISBN: 0-9623447-8-8
Hardcover ISBN: 1-883398-04-5
Signed & Numbered Hardcover ISBN: 1-883398-01-0

Printed in Hong Kong

Thank you for trusting your own eyes.

—De Es

FORWARD

Today's world of contemporary art is sadly barren of true invention. A parched wind blows through it, often dispersing the seeds of vital imagination before they can delve root and gain succor. Fortunately, however, one such seed has found purchase. Nurtured by Ernst Fuchs and the Viennese School of Fantastic Realism and bathed in the inspiration of Francisco Goya, Salvador Dali and others, this seed has come to sprout and flower, in color and structure both unique and sublime. The banalities are shunted aside and the merely decorative are consigned to the shade, as truth and talent force their way to the fore.

From his earliest beginnings as an artist, De Es Schwertberger blazed his own path of style and content. He resigned Vienna's Academy of Fine Arts when a professor strove to mold his work into more accepted confines. Instead, De Es went on to study the Old Masters style of painting with Professor Fuchs. Under his tutelage, De Es developed his remarkable technique for detail, often spending several weeks on a single canvas. You will not find the slap-dash approach to painting that so many of today's artists favor.

Hieronymus Bosch, Pieter Bruegel, Francisco Goya, William Blake, Rene' Magritte, Salvador Dali… all fathers to today's masters of fantastic art. Their offspring take from them knowledge of what can be achieved with an unfettered imagination and a brush wielded with talent and a strong hunger for labor. Gradually the students emerge from the shadows cast by their masters. De Es Schwertberger, H.R. Giger, Jacek Yerka and a coterie of talented others. It is their time now. They no longer reside hidden as their own works glow with an intensity of vision so affecting and potent that no shadow may be cast upon it.

De Es is that rarest of artists who can captivate with color *and* with form, both possessing equal measure of impact. His wondrous imagery makes soar the imagination and provokes the spirit to new depths of reflection. At its very core, the art of De Es is a synergistic oneness of powerful forms and striking colors. A singularity of beauty, bound with wisdom.

—James R. Cowan

I began to take myself seriously as a painter when I was drawn into the sphere of influence of the "Viennese School of Fantastic Realism." This is not an educational institution, but the name of a group of Viennese painters who emerged after the war with the painterly tools and methods of the Old Masters in order to digest the horrors and traumas of the war. They delved deeply into the psyche of humanity to "gather the shattered spirits" through the alchemistic processes of art. This was also the same time in which "Modernism" gathered momentum and abstract and conceptual movements proceeded to dump a thousand years of representational illusionistic tradition. The "Fantastics" were intriguing—made the heart beat faster, were loaded with meaning and mystical flavors of all kinds and intensities. They displayed unbelievable fireworks of skill and wizardry. Naturally, I was pulled into this direction.

When I met Ernst Fuchs, the prophetic central figure of the "Fantastics," he invited me to join his private course on "The Painting Technique of the Old Masters." I repainted one of my works, THE WHY, under his supervision in this technique of "building up" a painting methodically on a solid ground. In this way, Fuchs helped me inject subtleness and discipline into the foundation of my art. For some years to come, I continued to apply the Old Masters Technique. It became the perfect tool to project the inner world as a precise illusion on the image plane. I then simplified it more and more in order to strengthen the content of my message. I pondered the mystery and the meaning of life, the riddle of the world and the problem of identity. I was a seeker and formulated my findings in my paintings. To see all and to show all was my credo. I was always struggling in my mind to discover "strong ideas": images that would say something original and valuable in a concise manner. I worked to create arresting images that would open a window to the deep matters of the self.

THE WHY

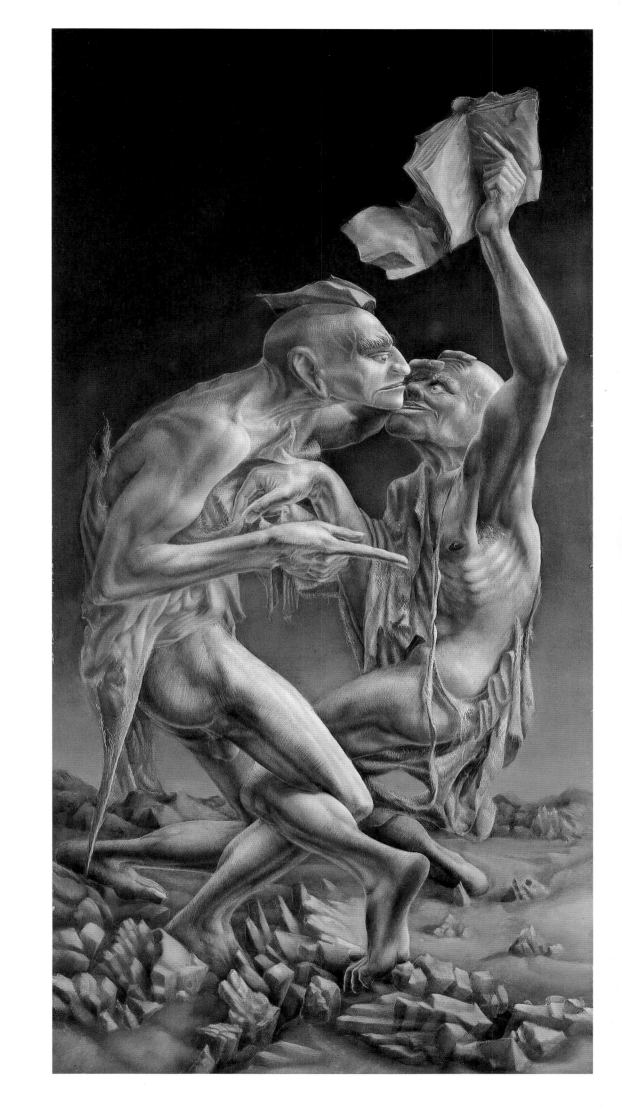

I was not a painter's painter who would squeeze the paints onto his canvas in a fury. In these early works I avoided anything that could look like a brushstroke. The onlookers always wondered how it was done. They were really quite mystified. That sort of response made me feel very good about my work, because that is how I perceived existence. There are no brushstrokes in life and only the creator knows how it is done. I am left mystified. Wondering.

The sense of mystery dominates the first decade of my work as an artist. The mood in a painting depends upon the setting of the light. This ambiance of mystery is evoked if the source of illumination is left unseen. The resulting mystery awakens the seeker in us and compels us on a quest to discover the light's true source.

Light and space are fundaments of illusion. The inner light and the inner space are the fundaments of reality. This principle guided my outer work as a painter and my inner work as a seeker.

The work is two-fold: The seeker yearns to see and the painter attempts to show the seeker what he has seen. "Seeking the light and showing the seeking" will lead to "Seeing the light and showing the light."

Know where the light is coming from.

THE MYSTERY

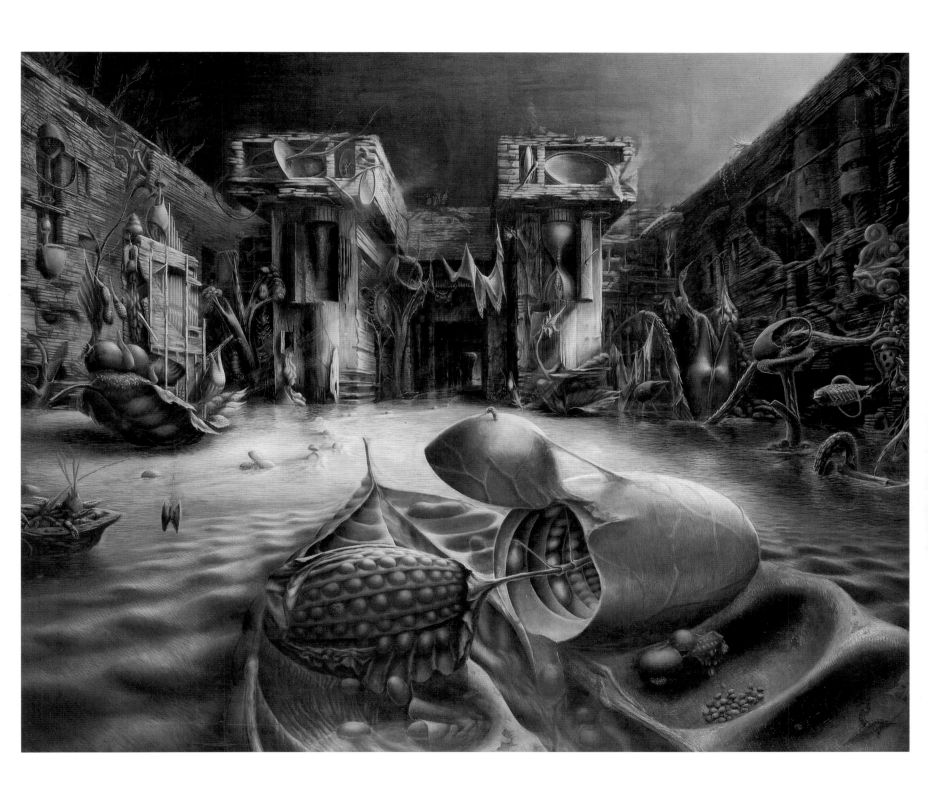

I enjoy the sensation of viewing a painting that provides the illusion of deep space. The deeper one can see into the painting, the more exciting the image becomes. The effect in NO END is produced by the elongated central perspective. I did not utilize any geometric tools or rulers as it would have taken me ages to work everything out to geometric perfection. Rather, I employed my experience as an Engineering School graduate to develop the painting strictly by my own senses.

In the case of central perspective, the subject disappears in the central point—also called the *point of escape*. I attempted to expand the spatial dimension beyond this point. My intent was to portray the desire of humankind to escape the confines of matter, space, and time, and grope for the dimensions beyond. We are tied into a structure of cosmic dimension and destiny. We want to find a way out. We attempt this through science, always expanding our macro and microcosm at the same time. As a result, we are constantly expanding our level of empirical knowledge. However, we fail to escape this material dimension and find the gateway to the beyond.

Contemplating these issues and experimenting with the possibility of elongating central perspective eventually led to the image at right. It was painted on a blue background with white in a few weeks of very concentrated work. The color blue always enhances the depth effect in a painting. It is always great fun to work out these distant details on the far horizon. It gives one the sensation of being vast—expanding far beyond the small limitation of our earthbound existence.

When I did this painting, NO END, I knew nothing of DNA, nor its structure as revealed by Crick and Watson. Later, when their book fell into my hands, I realized the obvious similarity between the double-helix structure and the construction of my painting. In both cases, there is an inner core with an outer shell twisted in a spiral, as though I had envisioned being drawn into the formula's molecular structure. The urge of the scientist to find the ultimate formula and the urge of the artist to find the ultimate truth spring from the same roots. It is born of the need to understand our prison so that we can eventually escape and move to the next stage of life.

Some of my more complex paintings contain a multiplicity of meanings. I call this process: *condensation of ideas*. A sort of maximalistic approach to art.

NO END

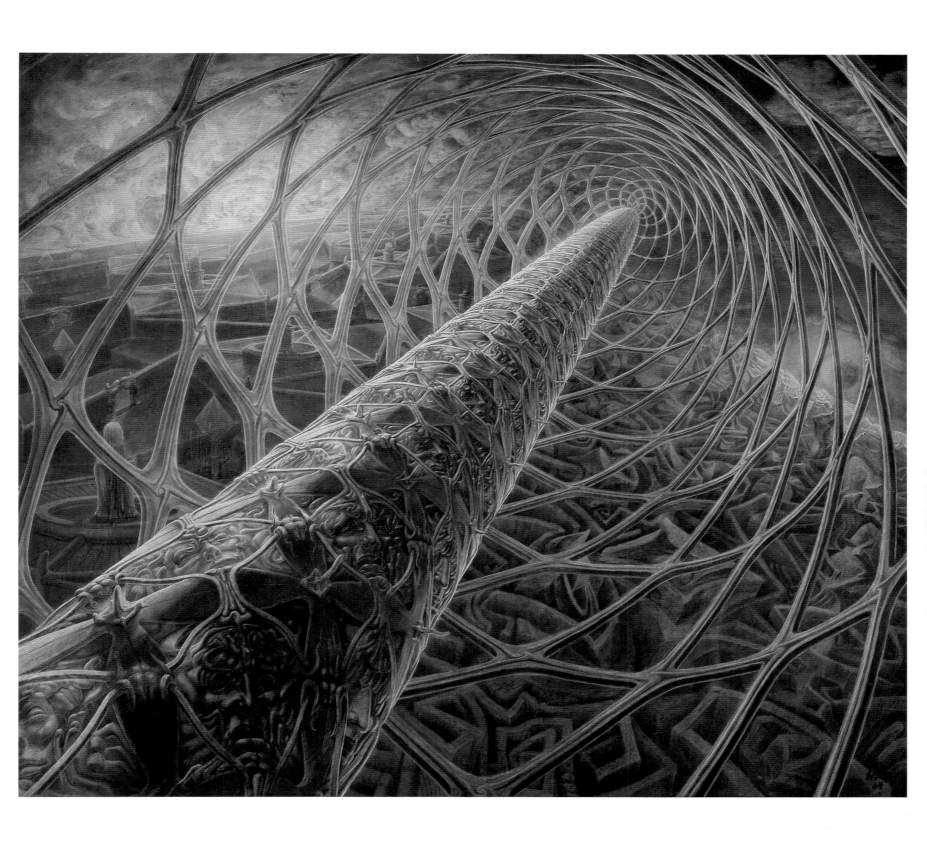

The navigator has laid out all his compasses and maps before him and has plotted the course of his ship far beyond the horizon. The wings of fortune have buoyed him and he discovers visions of his arrival mirrored in the "crystal egg of ancient wisdom." When a ray of the divine light of inspiration strikes its inner core, a mantle of stillness cloaks the site of departure. The trajectories of the course of the journey begin to curve inward. The ships in the harbor are abandoned and the symbols on the maps fade away. The inner voice speaks: "You are already here. You never left."

THE INNER JOURNEY

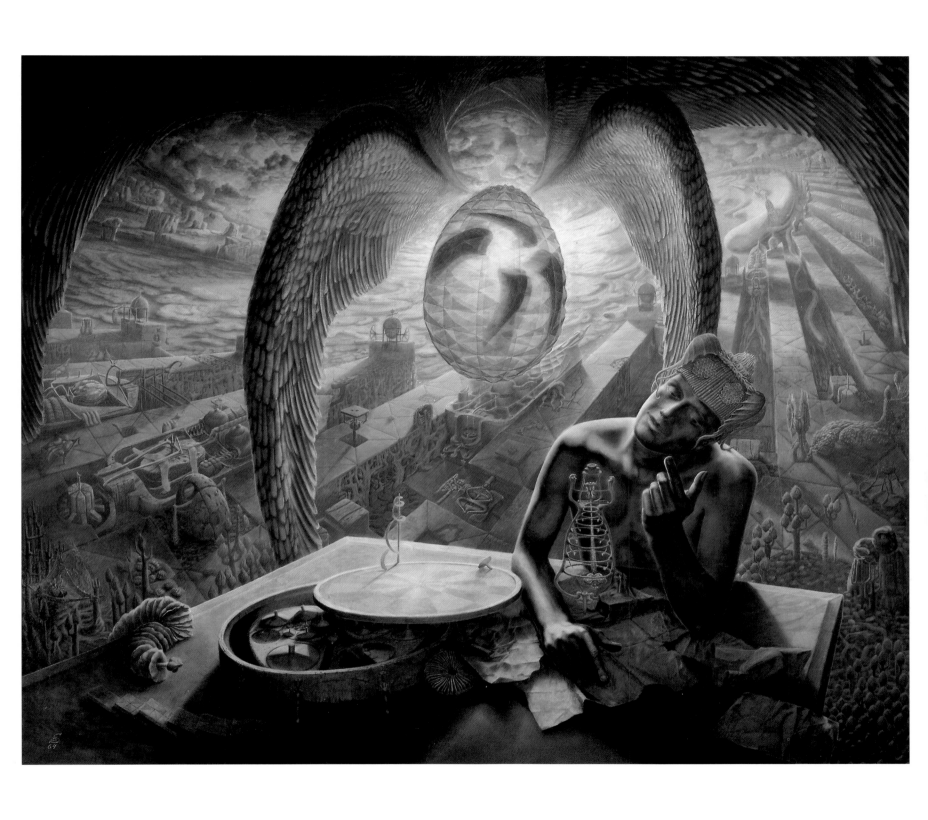

The Two.
When two people come together, a strange phenomenon occurs. Each tries to establish superiority over the other. This is either accomplished by growing over the other, or cutting the other down. As a result, each develops defense mechanisms to prevent being cut down as well as improving its own state. Virtually all of human attention is involved in this process. It has become so complex that the original state of human oneness has been quite forgotten.

THE STAGE

Are we on a stage?
Is this a performance?
What are the roles?
And why are we smiling
while the stage is burning?

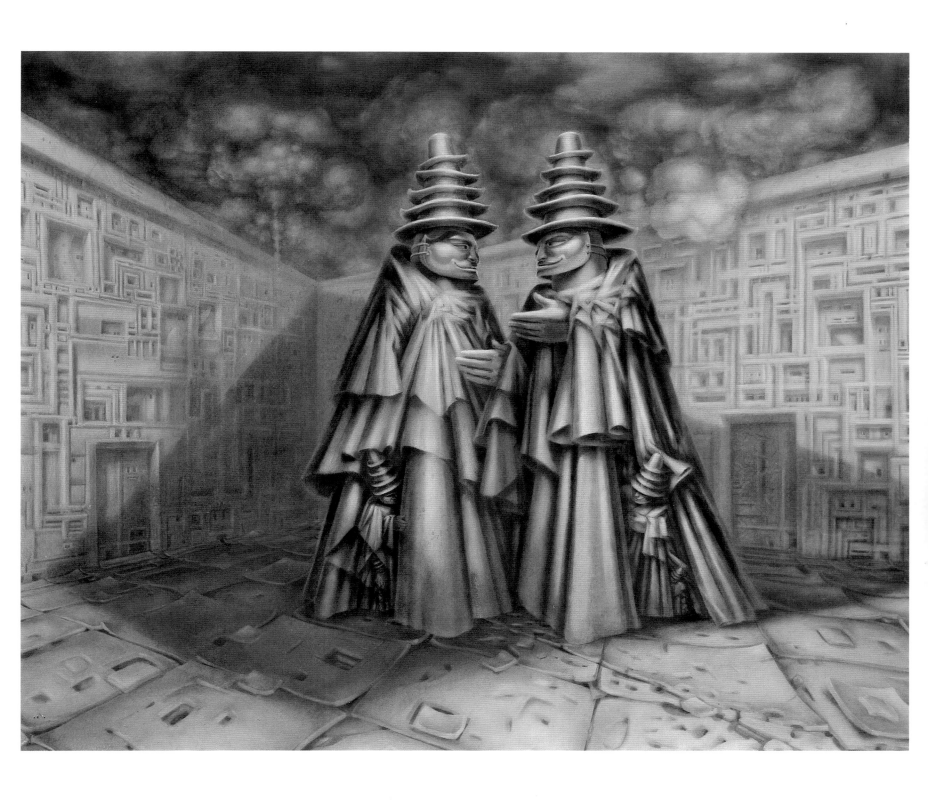

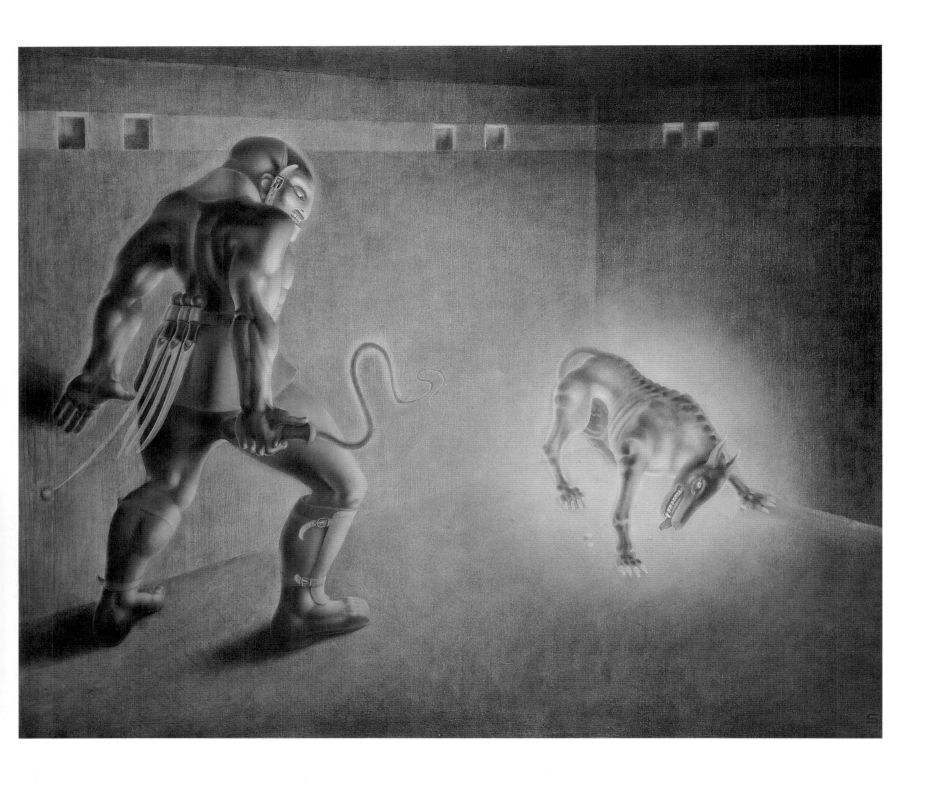

THE TAMING

THE LESSON

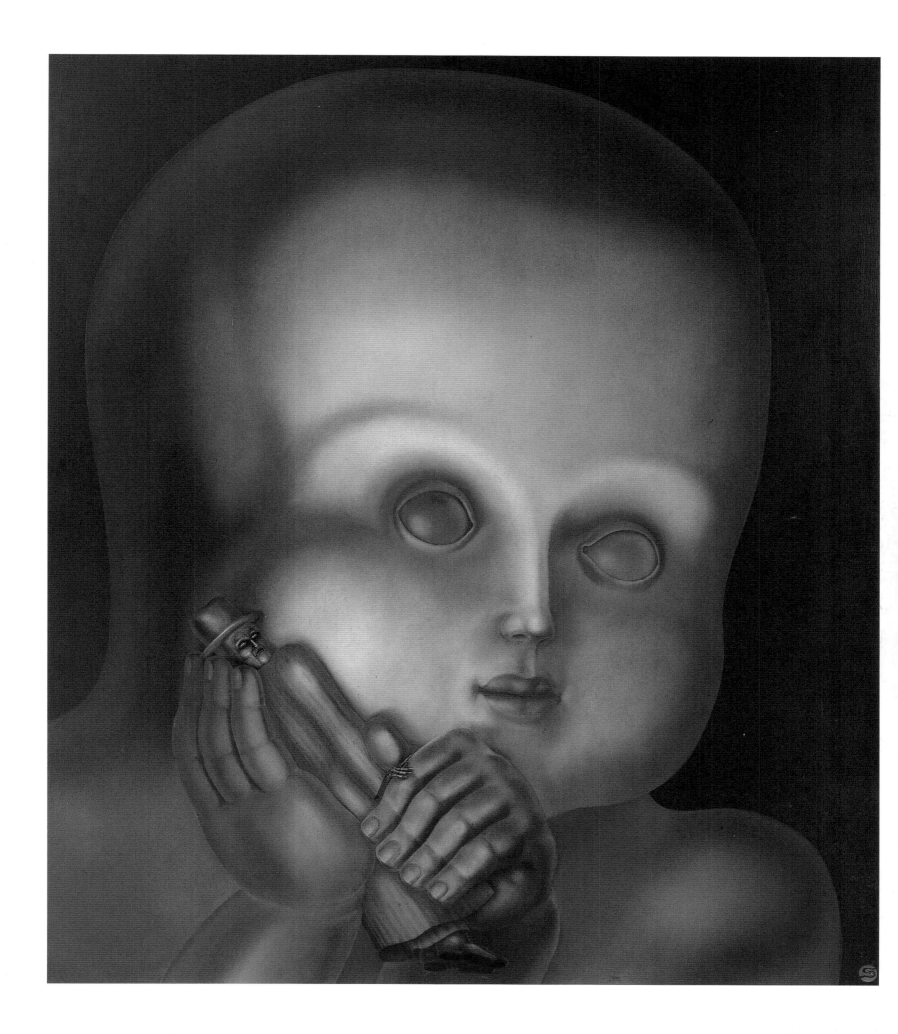

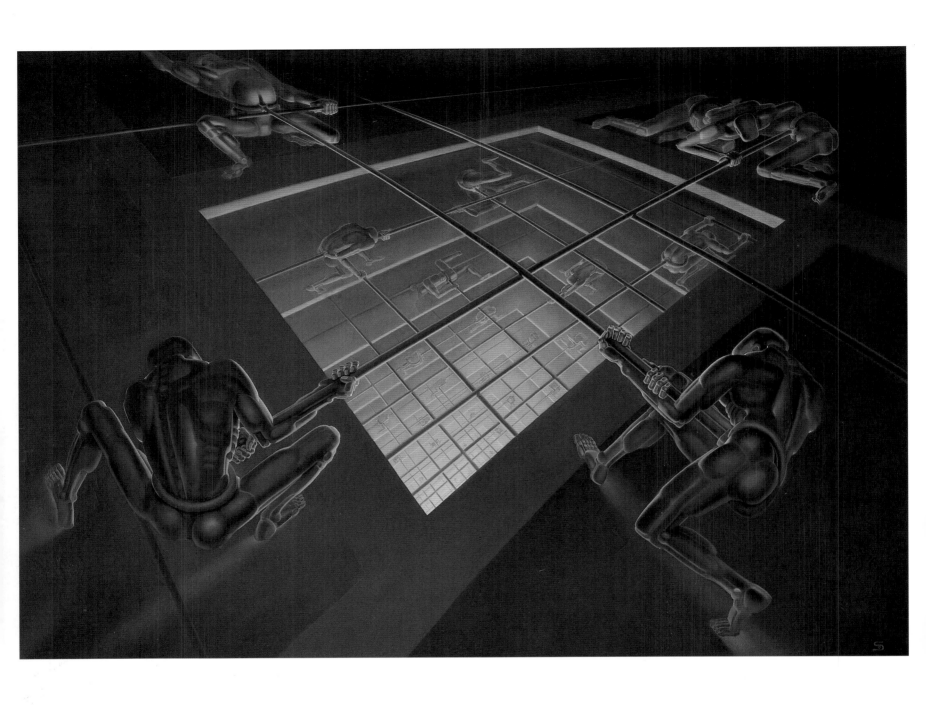

BLIND FORCES

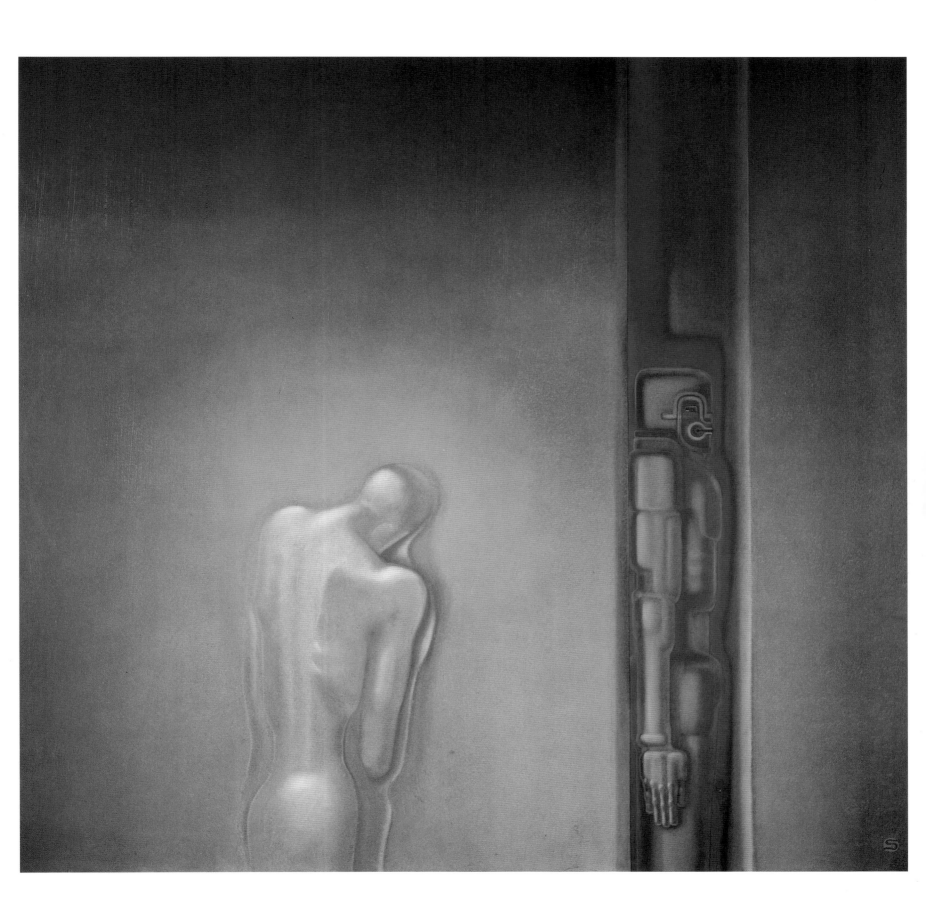

The Threshold
Step out
Step out of the box
Step out of the circle
Step out of the shadow
Step out of the screen
Step out of the machine
Step out of the pattern
Step out of the line
Step out of the code
Step out of the sign
Step out of the norm
Step out of the mold
Step out of the form
Step out of the dream
Step out

THE THRESHOLD

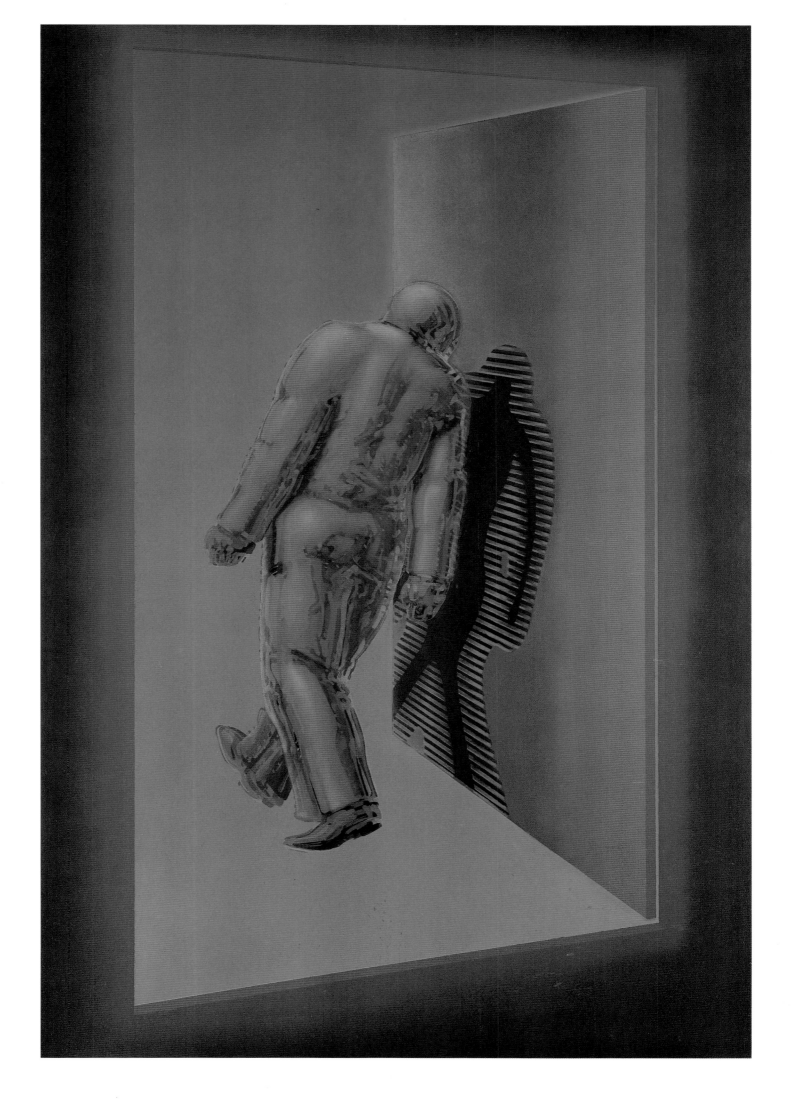

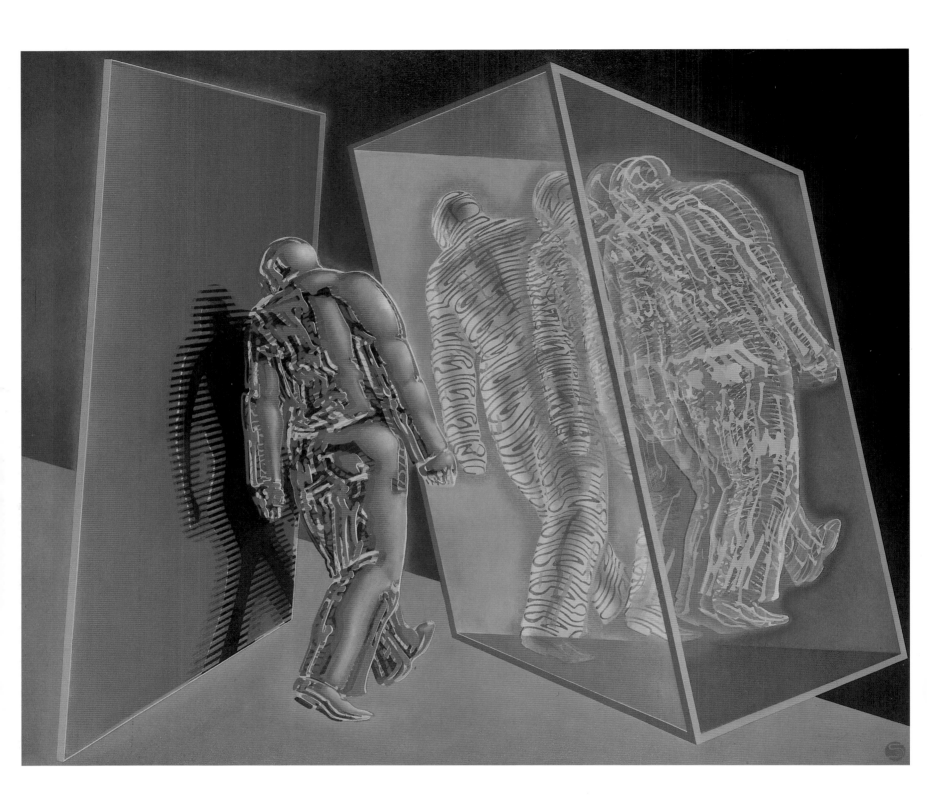

INTO IT

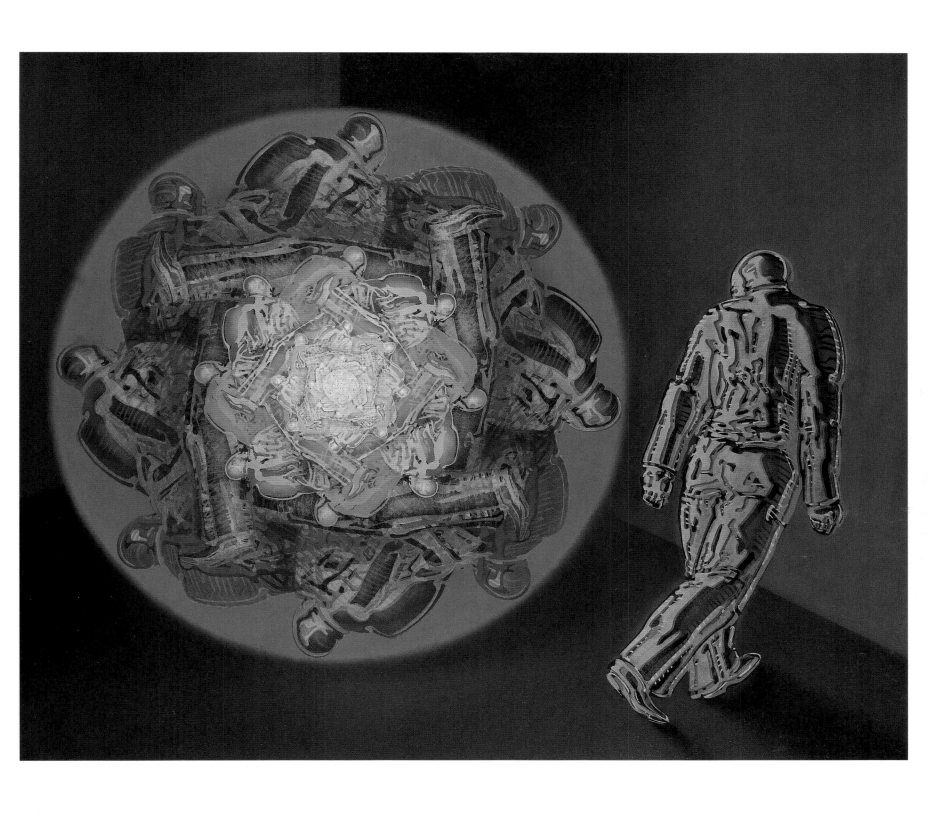

COSMIC SURPRISES

THE TRAP
How great is the expansion
when we find out
how limited we are

THE QUEST
Man made shadow
Can he make light?

THE BLOW
When means are frail
the deed will fail
When means are strong
the purpose is wrong

THE CUT
Old dreams in front of new ones
and new dreams in front of old
Both disturb the view

THE ROOTS
All rests on the same ground
Yet the ground rests nowhere

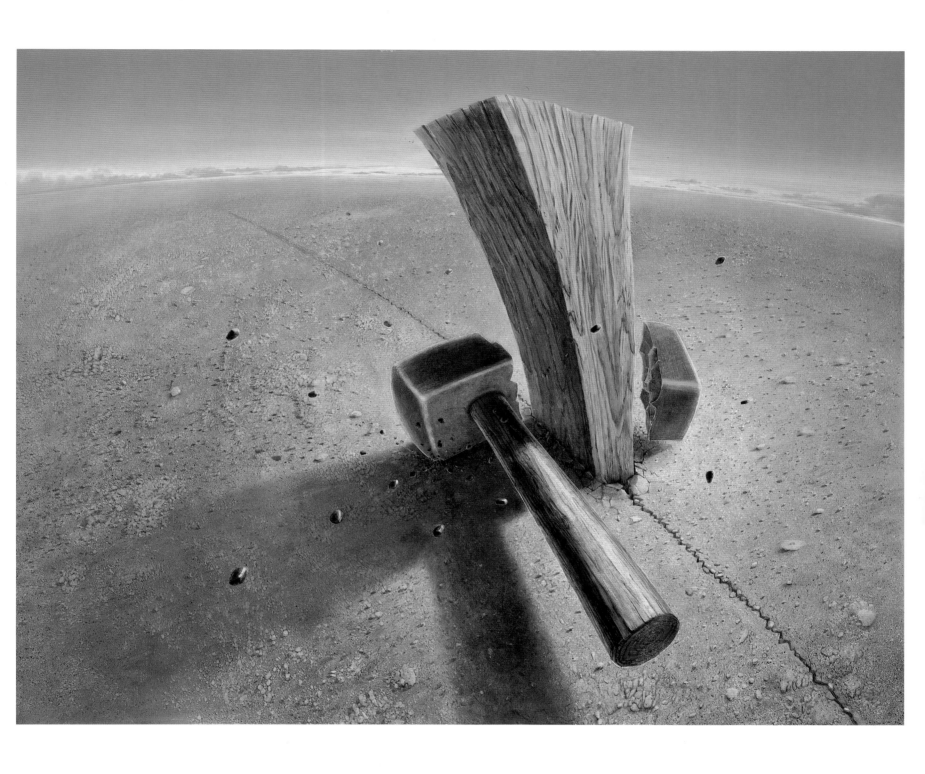

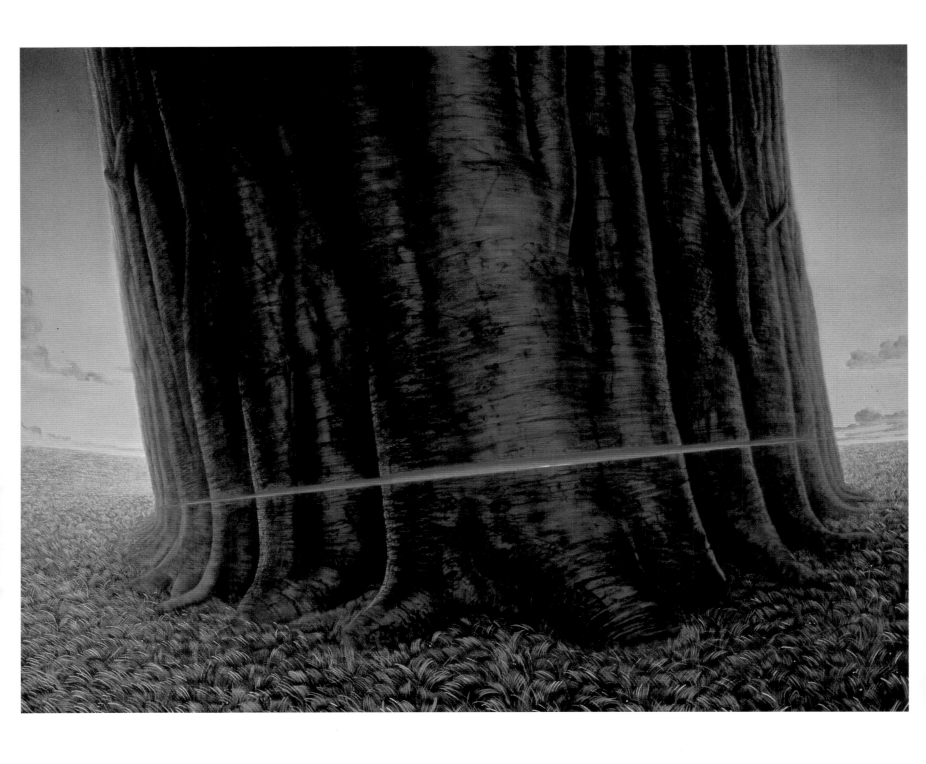

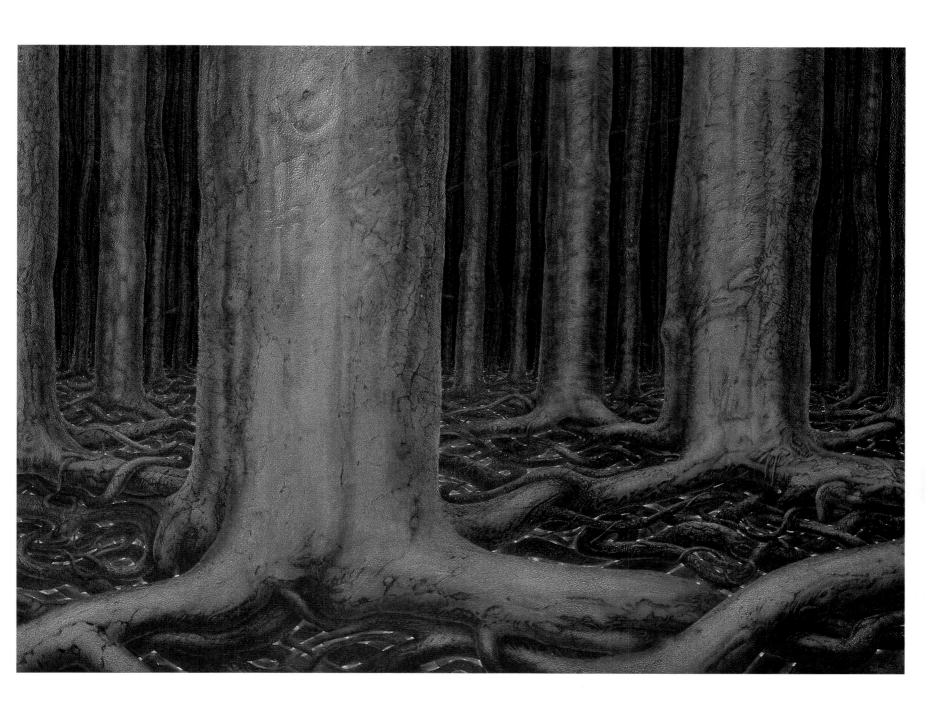

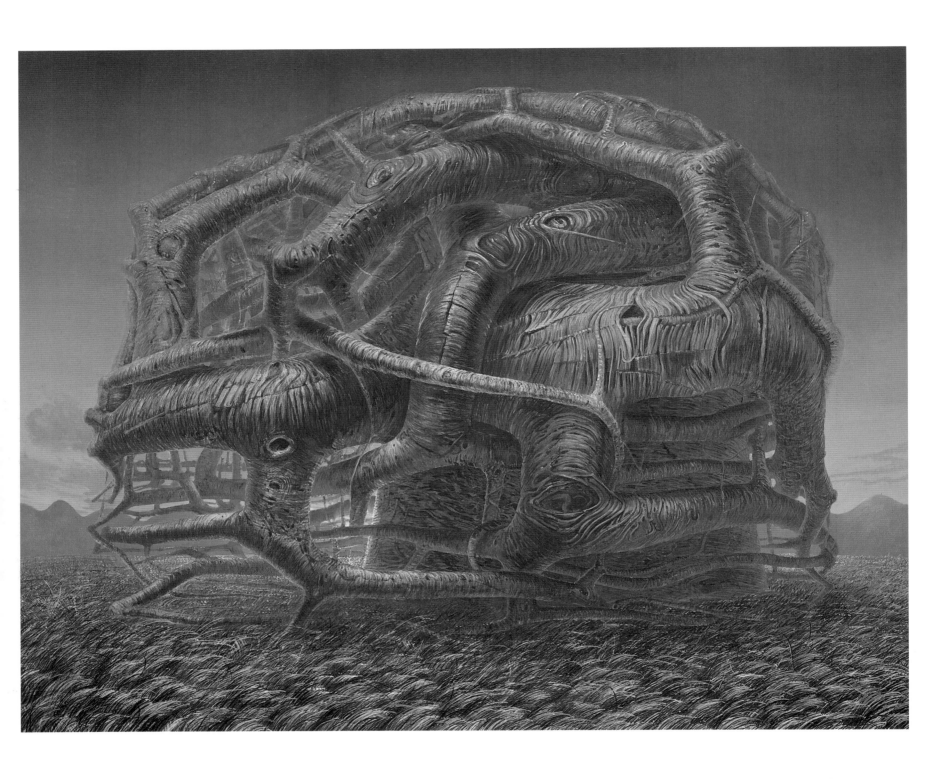

THE CROWN

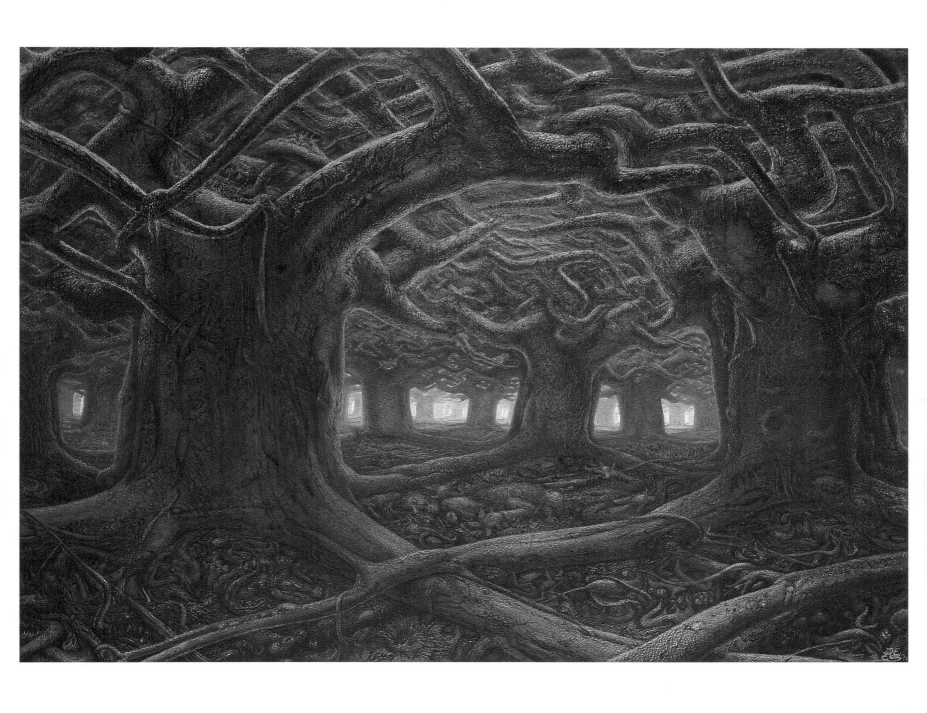

THE STEMS

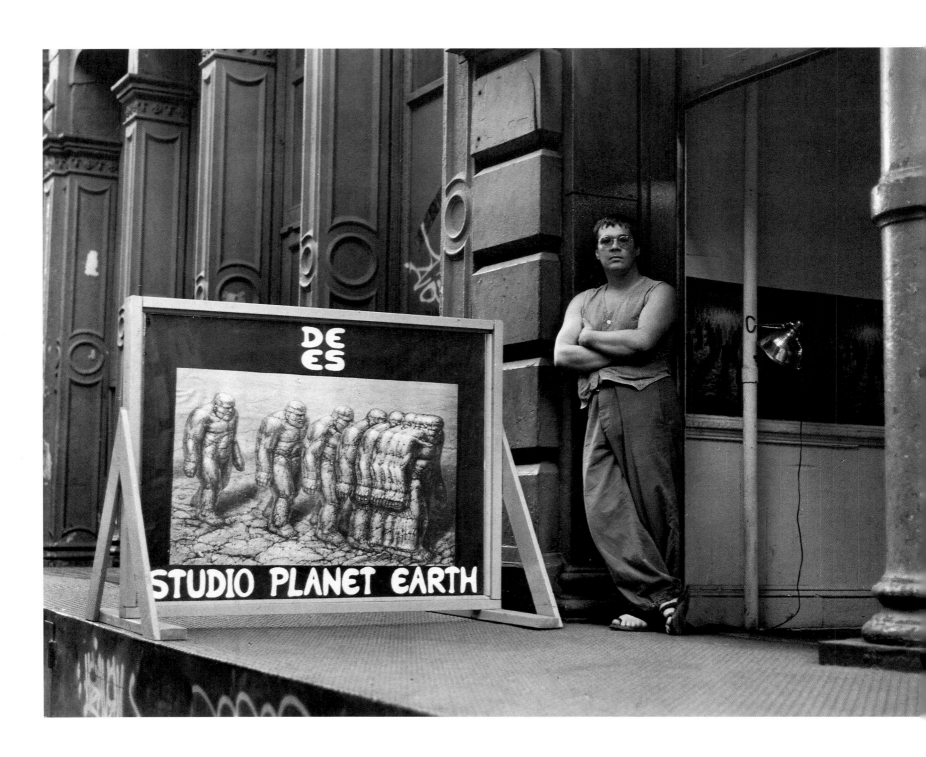

THE FORMULA
The Stone and the Light

The invention of *strange phenomena* took place in the series of works called **Cosmic Surprises**. They were demonstrated in the simple setting of nature. Rocks split down the middle were hovering over meadows. Forests were cut as a whole and lifted up. There was a sequence where everything was stripped down to the bare rock. This period displayed a world in which everything was composed of the same material: **Stone**. This reduction of the surface texture placed the emphasis upon ideas and supported the metaphysical notion that *everything is made of the same stuff—the stuff of illusion*. The **Stone Man** with his **Stone Mind** attempted to solve the riddle of the origin of **Stone**. He discovered that the origin of **Stone** is **Light**. **Stone** is **Heavy Light** and **Light** is **Light Stone**. The **Transformation** of **Stone** into **Light** and **Light** into **Stone** together with the **Transformation** of **One** into **Many** and **Many** into **One** opened up the book of interactions of **Stone** and **Light** with the **Stoneman** and the **Lightman** (each element singularly or multiplied). The overwhelming presence of the **Stone** mirrors mankind's solid identification with materialism. Seemingly, mankind, in its struggle to survive, yearns to outlive the **Stone** by becoming even more solid than **Stone**. Accordingly, he attracts all worldly matter, which threatens to bury him beneath its mass. Fortunately, there is the **Light** and the **Lightman** to remind us of our spiritual origins. *Under every surface of stone, there is a core of light.*

Our world has become a tremendously complicated structure of matter, energy, space, and time.

We, the spectators, have ourselves become so complicated that we cannot understand anything at all, anymore.

The complexity of inner-reality is confronted with the complexity of outer-reality.

The fate of the overly complex is disintegration.

Threatened by both inner and outer disintegration, we find ourselves forced to turn our attention toward the essential: **To recognize how the inner universe is connected with the outer by truth.**

When we want to understand our creations, we have to understand ourselves.

When we wish to fully understand something we are observing, we must fully understand who is looking.

If our vision were clear, we would find ourselves at the bottom of everything.

But all we can get by looking is—pictures.

Utilizing the machinery of our mind, we seek to discover what is behind, underneath, and inside.

Through the solid walls of reality, we want to trace a path to transparency, emptiness, and light.

We disintegrate what we see into its fundamental components: Reality. Imagination. Nothingness.

Reading the story of the universe backwards is our method of reaching the beginning.

We encounter all the images which form and direct our wants, needs and urges imprinted on the core of our mind.

We discover pictures there, as if carved from stone, prevailing through time and revealing what powers are holding the world together.

If we could *read* these pictures, our vision would grow clear.

We would find ourselves at the bottom of everything—holding it all together.

Artist's Statement 1974

ORDER

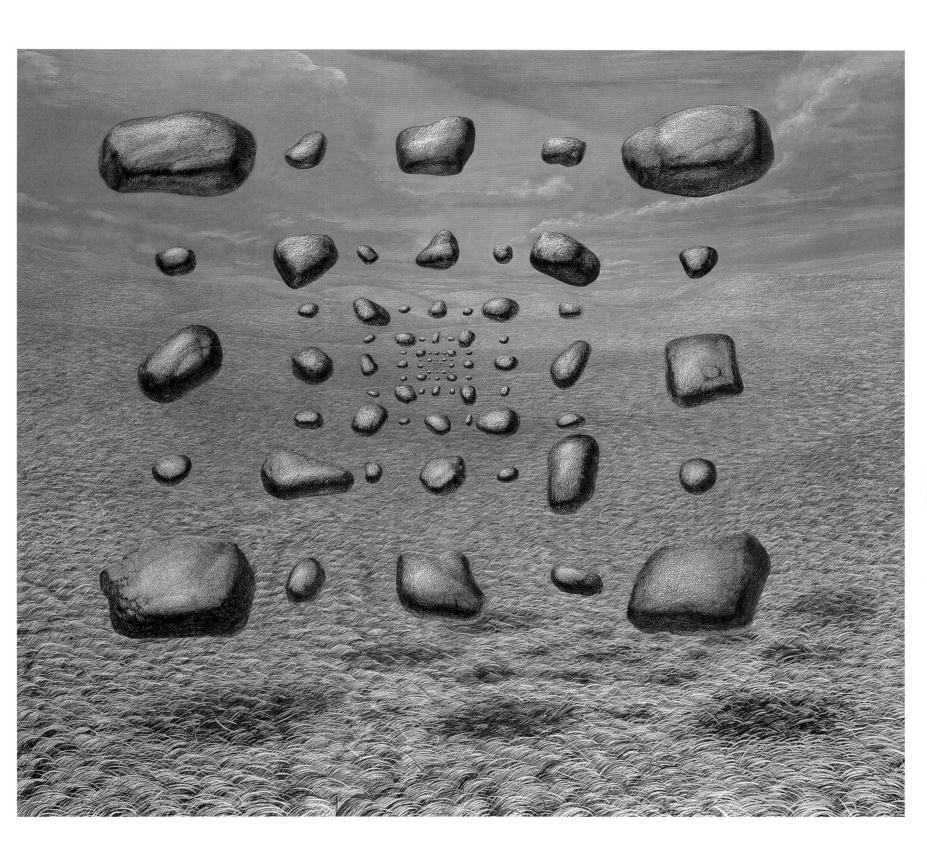

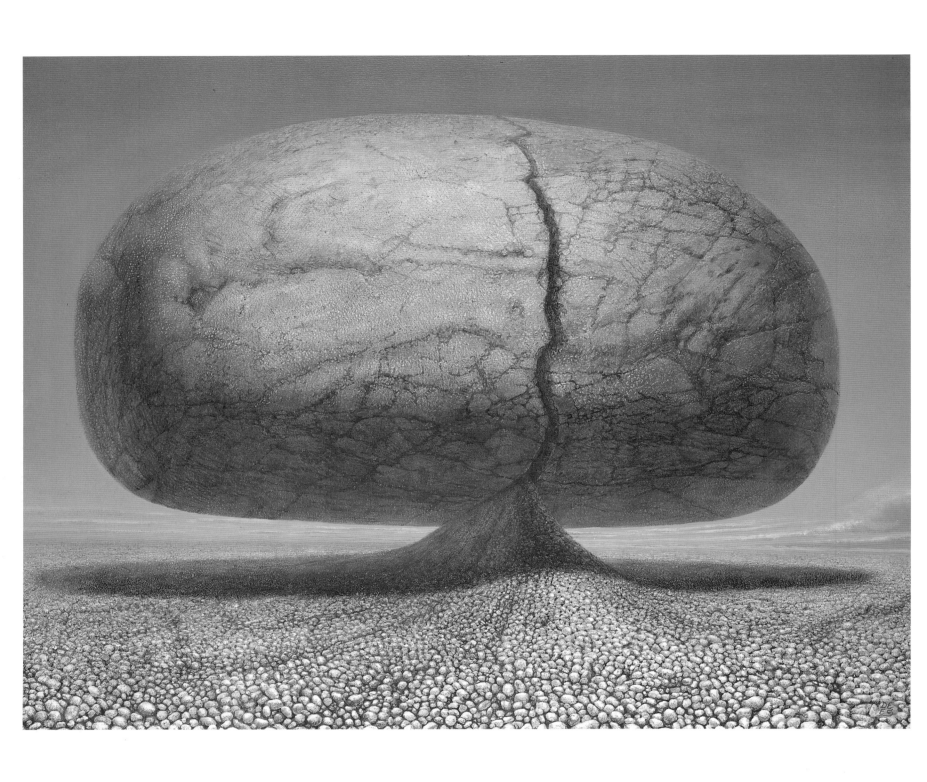

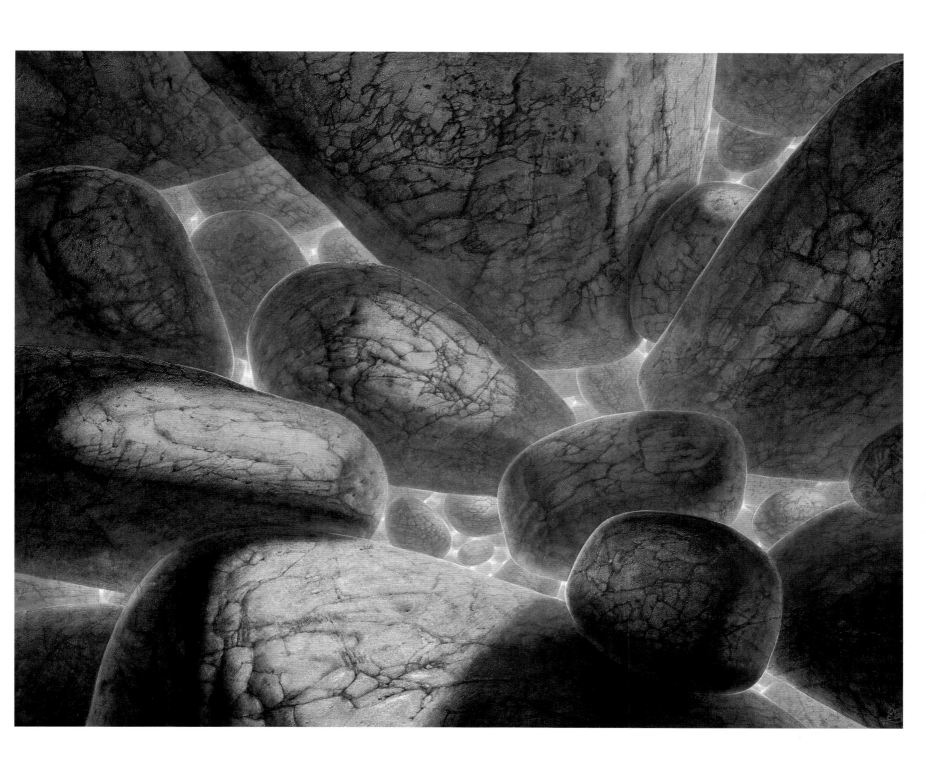

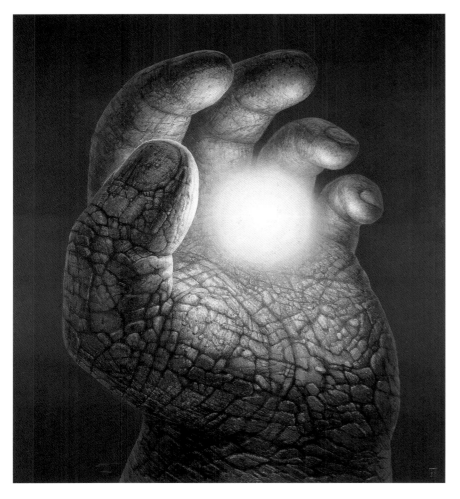

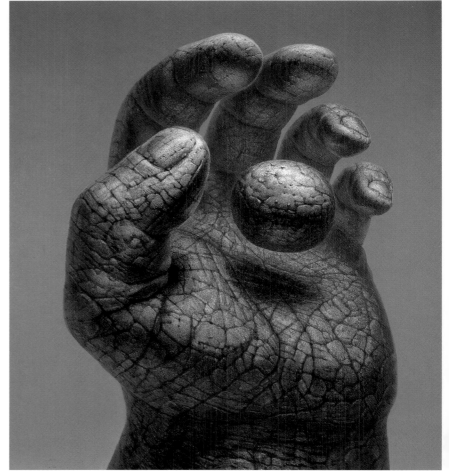

Seeing it
Getting it
Holding it
Letting go

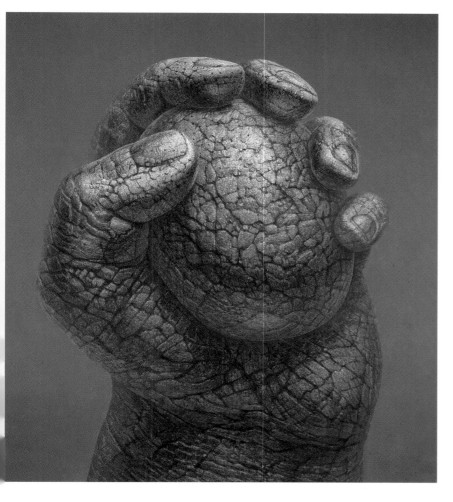 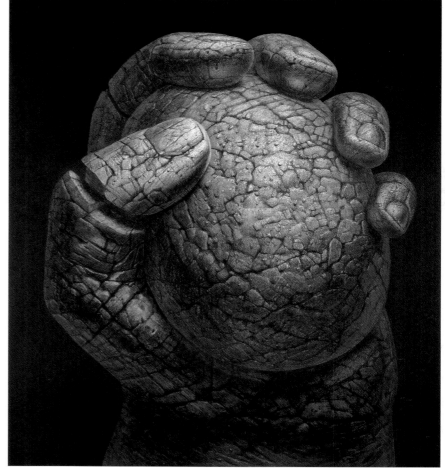

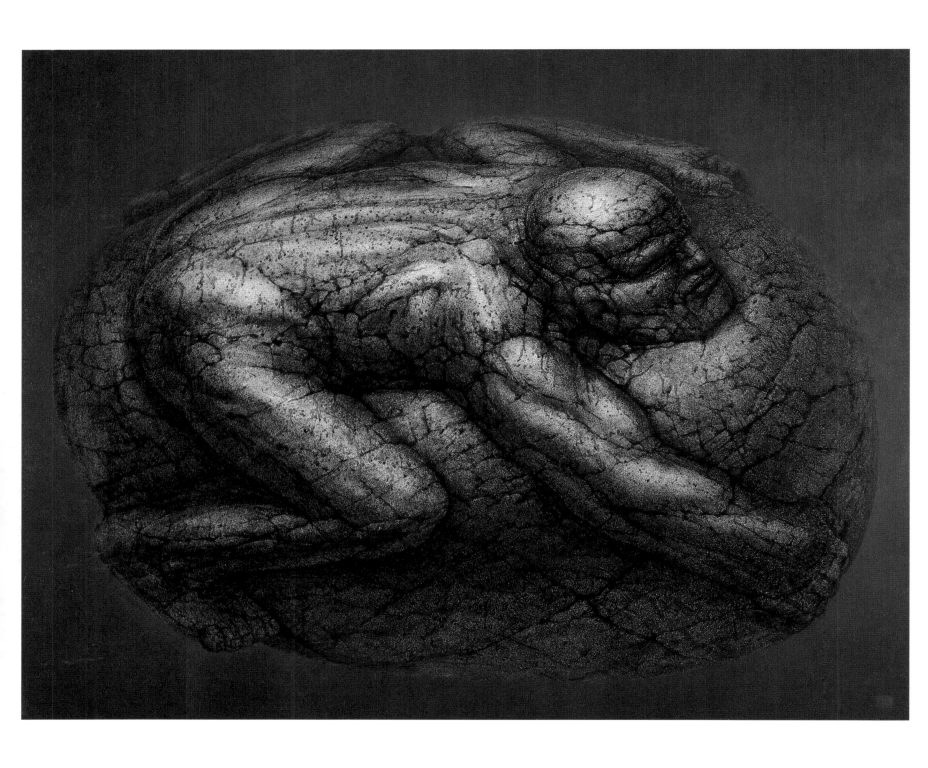

POSSESSION

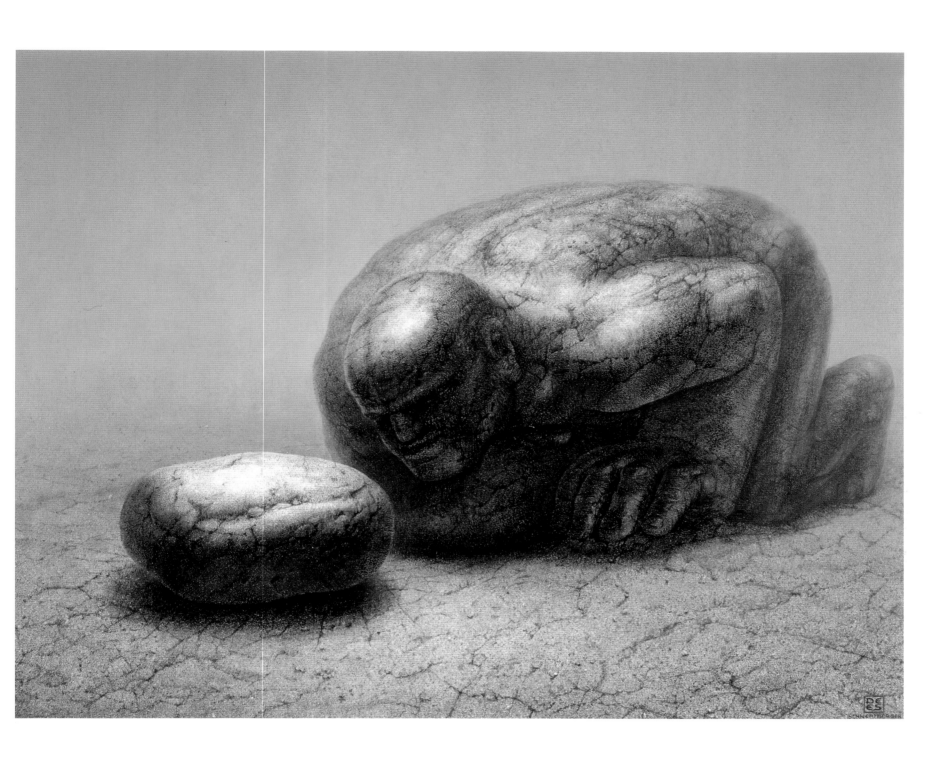

IT IS ME

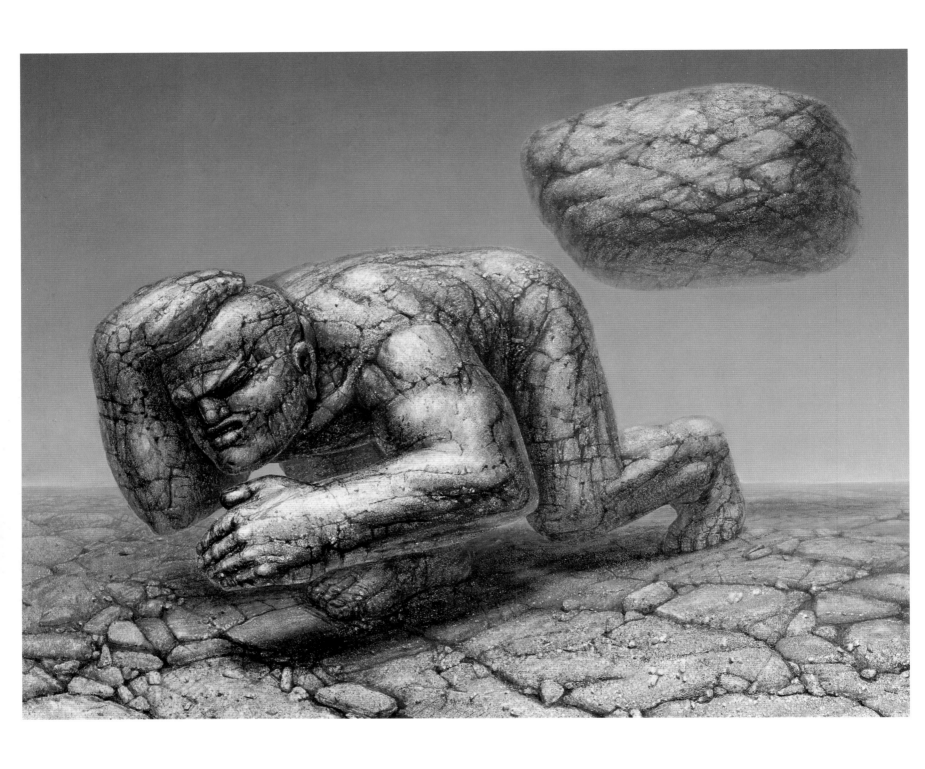

EFFECT

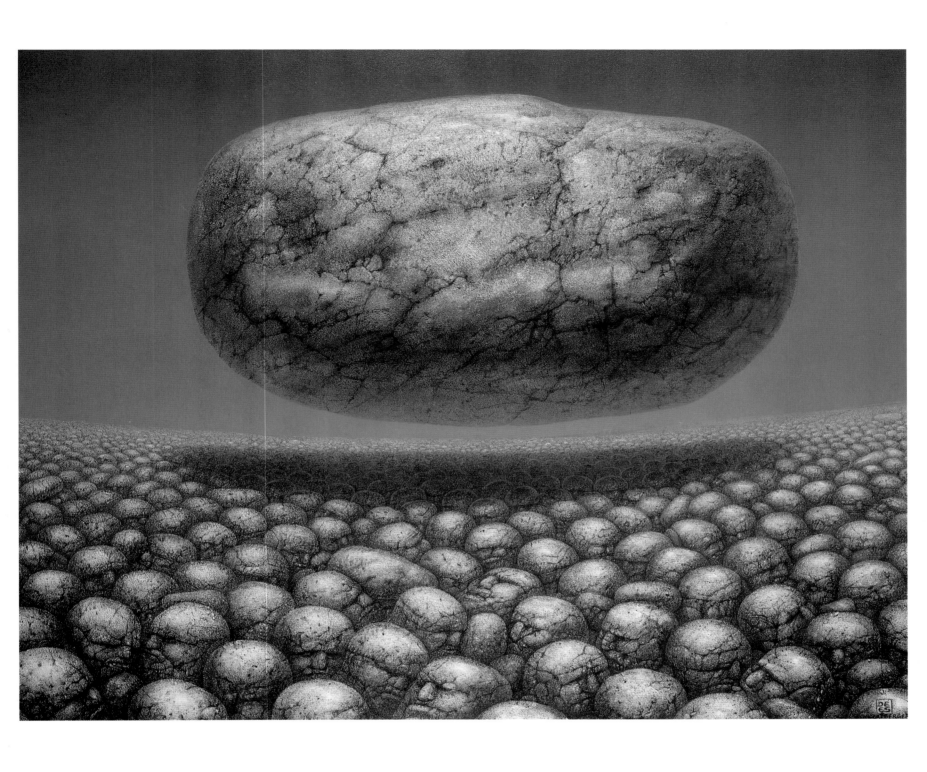

This is the right panel of the triptych THE JOINING, also called WHERE DO YOU STAND? The left panel is titled THE BLACK HOLE, the center THE GREY MASS, and the right is WHITE LIGHT or VISION ONE.

The paintings of THE JOINING measure three-by-two meters, each. The triptych was completed in 1977 after nine months of work.

THE JOINING is a focusing device—a generator of connective energy—a tool for transformation, created for the entrance hall of the DOME OF PEACE.

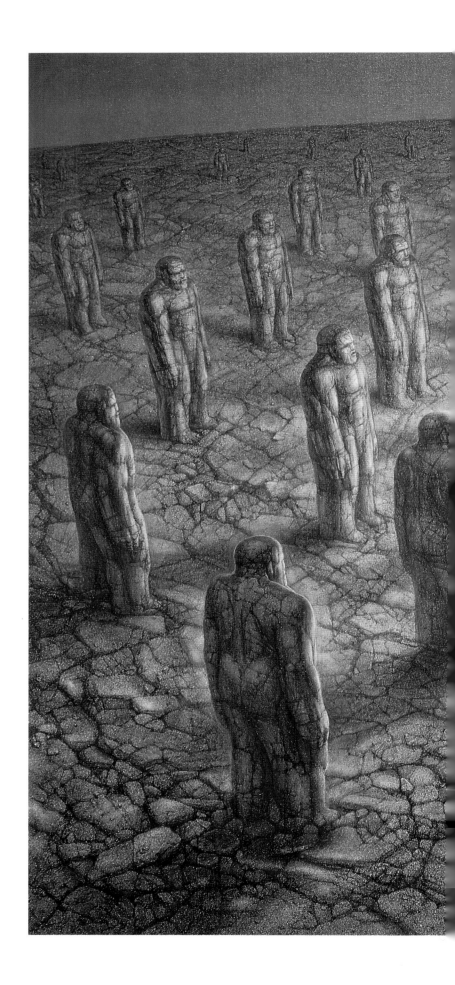

THE JOINING

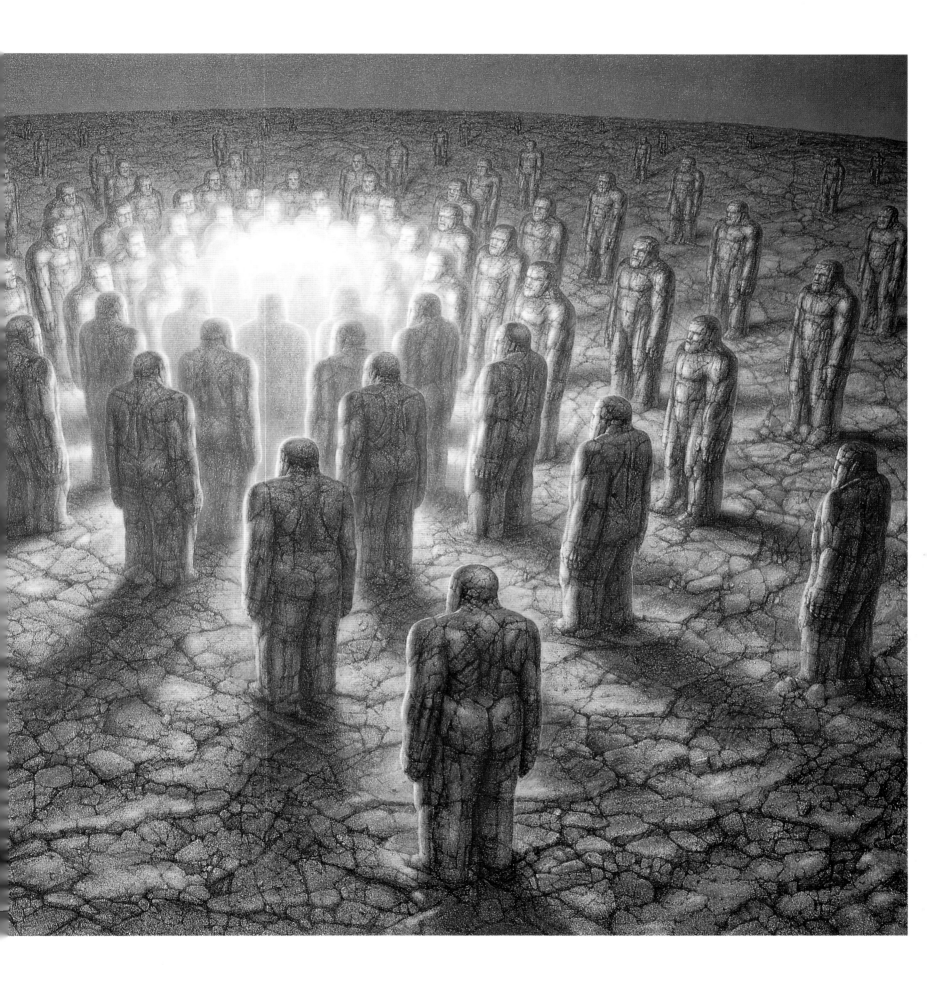

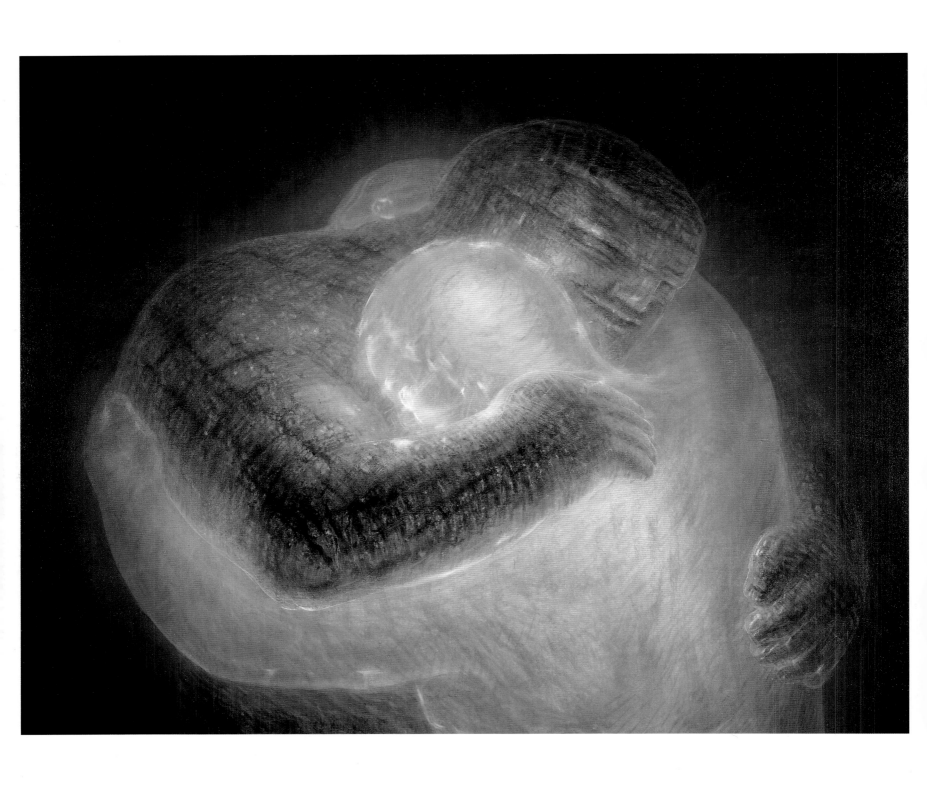

EMBRACE

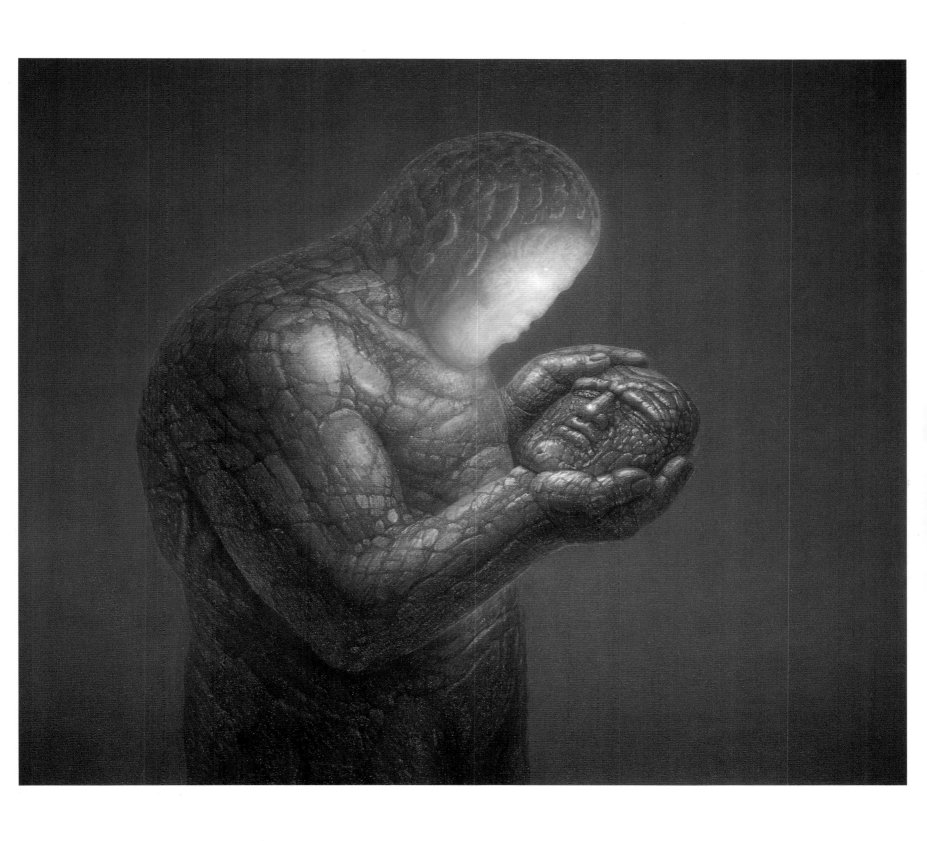

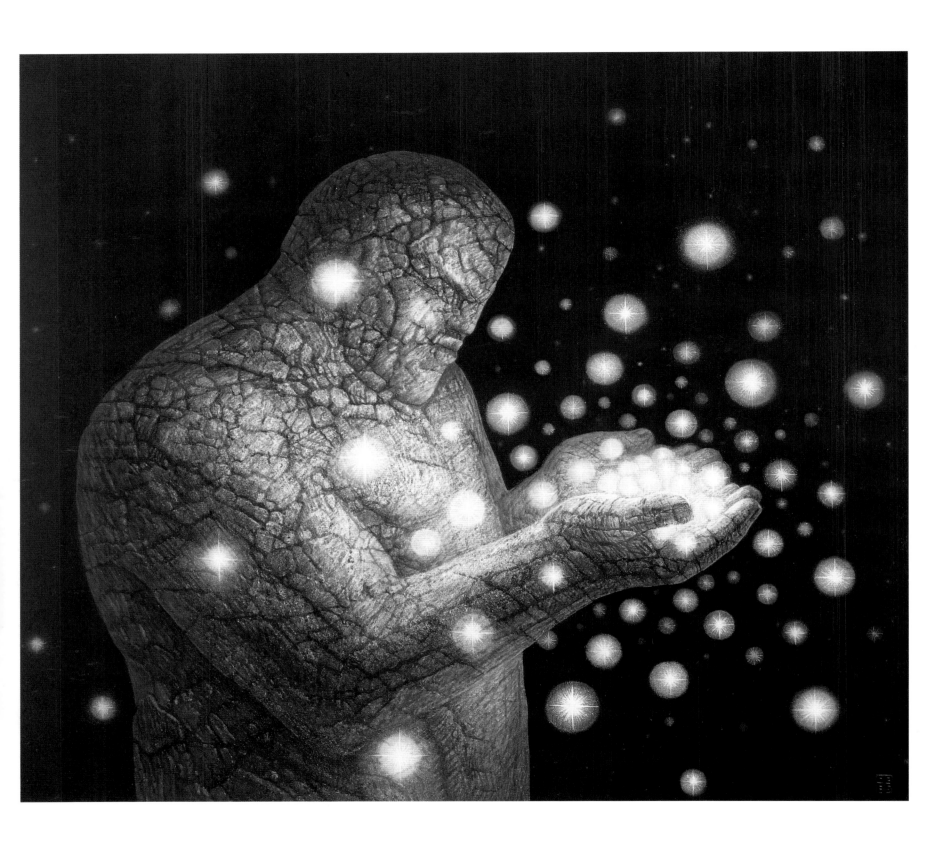

STAR SEED

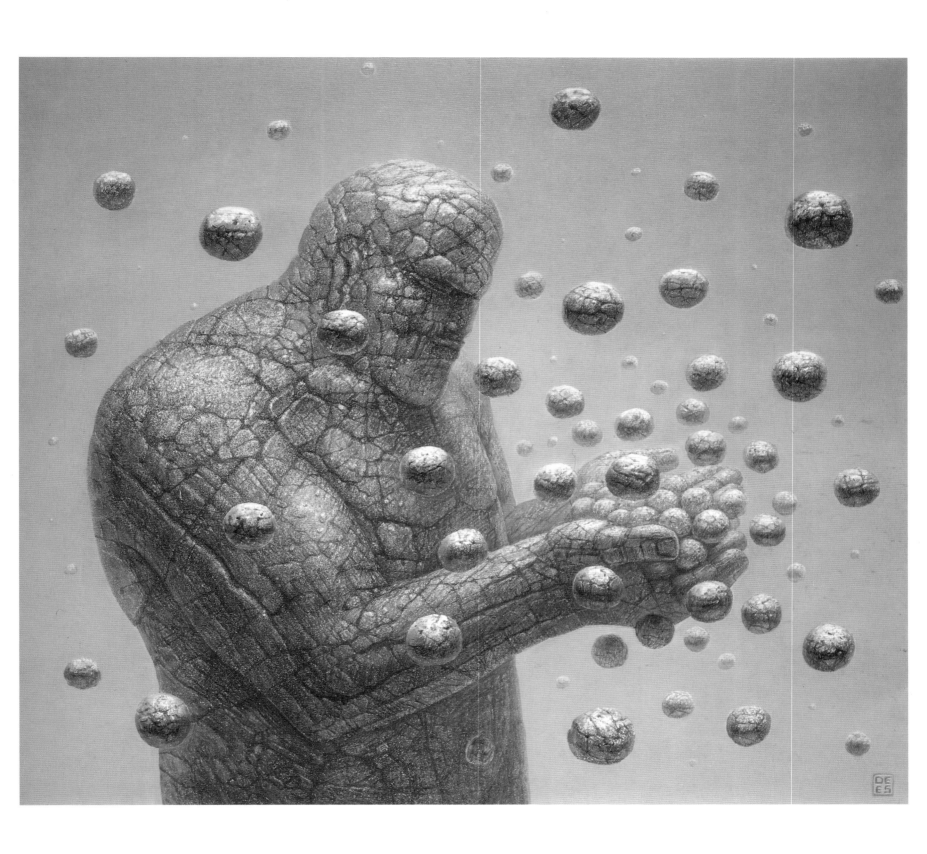

FULL HANDS

TRANSFORMATION
The Dance Around the Light of Life

Soon after the completion of THE JOINING, I lost interest in painting cracked stone surfaces. **Stoneman** evolved into **Lightman** and through their synthesis came an entire thread of new ideas, offering a new direction for my work. The excitement, however, was short-lived. But when the grass, which I had banned from my work for quite some time, forced its way back through my brushes, my entire world began moving. Brushstrokes turned into blades of grass and the stone transformed into grass. In a series called TIME PORTALS, I played with the juxtaposition of stone and grass textures. Soon the balance tipped and the brushstrokes became longer and longer in violation of my once iron-clad rule of "never to show brushstrokes" in my work. The grass turned into bushes, vines, trees, forests, and jungles. When I used wider brushes, the upward flow of the vegetation turned into water. When I altered the colors of this serpentine movement from green-blue to orange-red, the fire element began to dance with the water element. The figure, which was bathed in all of these various elements, lost its stiffness and adapted its movements to the flow of the environment. It changed from a male into a female and suddenly the repertoire of my subject matter had burst out from the grayish duality of Stone-Light into the colorful kaleidoscope of the "Cosmic Dance of the One-Being with the Many-Beings." This artist's epiphany completely prevented me from focusing on a single canvas, but drove me to work on a sequence of paintings in order to satisfy my sense of "wholeness." All of the universal themes of the yearnings of the human heart for enlightenment should be integrated into it: the journey to the light, the dance of joy, goals, ideals, and pathways to the beyond and to the light of life. All of my basic ideas should align themselves into an all-embracing design, but still leave enough space for new spontaneous transformations, new discoveries, and explorations of the full spectrum of painterly energies and expressions.

The wild dynamism of my transformative method was nurtured by the vision of "Humanity awakening as a oneness." I maintained a large studio at street-level in Soho. My door was always kept open to the public, even while I was in the midst of painting. I called it, STUDIO PLANET EARTH. The triptych, THE JOINING, evoked some deep responses in the hearts and minds of my many visitors. Mostly rather strange and uniquely creative characters were attracted: members of diverse New Age movements and communities, spiritual seekers, heralds of the Second Coming, spaced-out people and space-people, dancers who danced with the paintings, musicians who invented their own instruments, and artists who had seen through the Emperor's New Clothes and longed for a return to spirituality in the art world, or created their own art-worlds, instead. They all shared with me their visions for a new, transformed humanity. Inspired by their energy and enthusiasm, my own vision for THE DOME OF PEACE began to coalesce in front of my inner-eye.

I intend THE DOME OF PEACE to be a CENTER OF INSPIRATION FOR HUMANITY and dedicated to the unity of mankind, world peace, and global culture.

Between 1980 and 1990 I created an enormous cycle of one hundred paintings, each measuring two meters by two meters and arranged in a vast circle. This TRANSFORMATION CYCLE measures nearly two-hundred feet in diameter and marks the basic dimensions for the DOME OF PEACE building. THE JOINING and the PLANETARIAN SCULPTURES are integral parts of it.

Since 1990, I am the custodian of this exhaustive work. Currently it is a mystery as to where and how the DOME OF PEACE structure will manifest itself. I believe it would be a marvelous event for the year 2000, marking the new millennium and signifying that humanity is ready for UNITED TRANSFORMATION and THE PLANETARY AGE.

OASIS

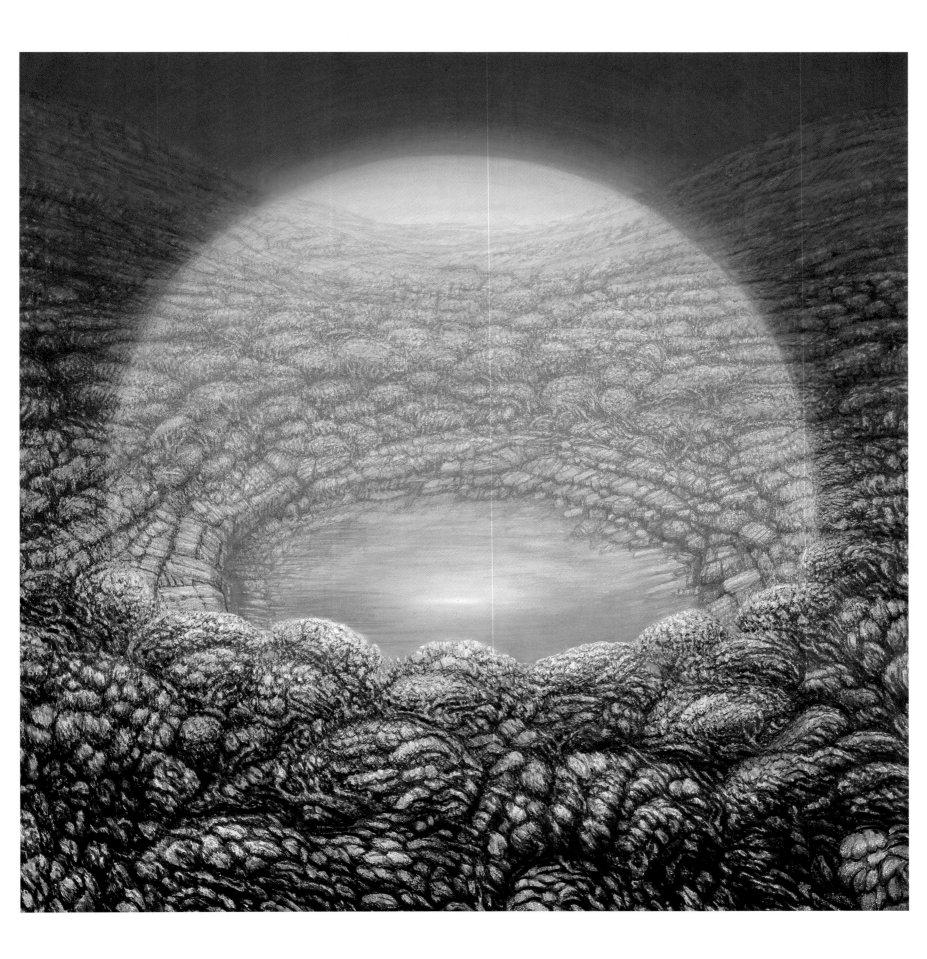

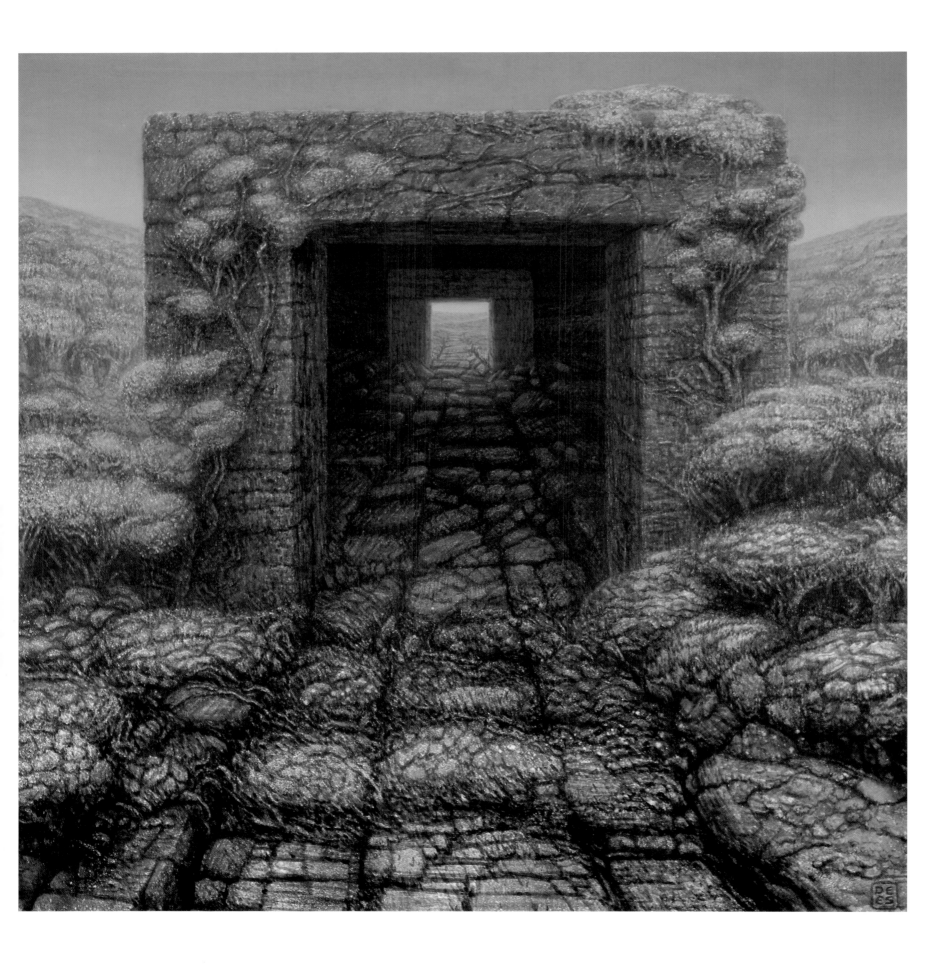

TIME PORTAL DAY

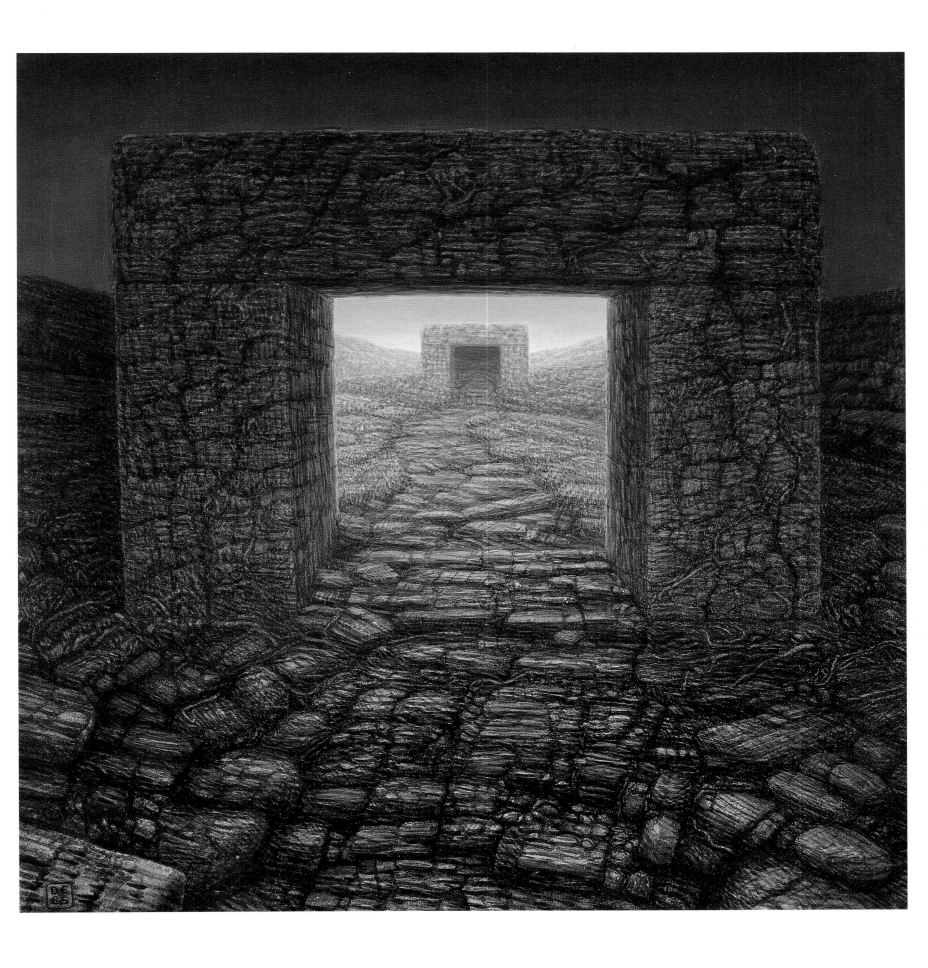

TIME PORTAL NIGHT

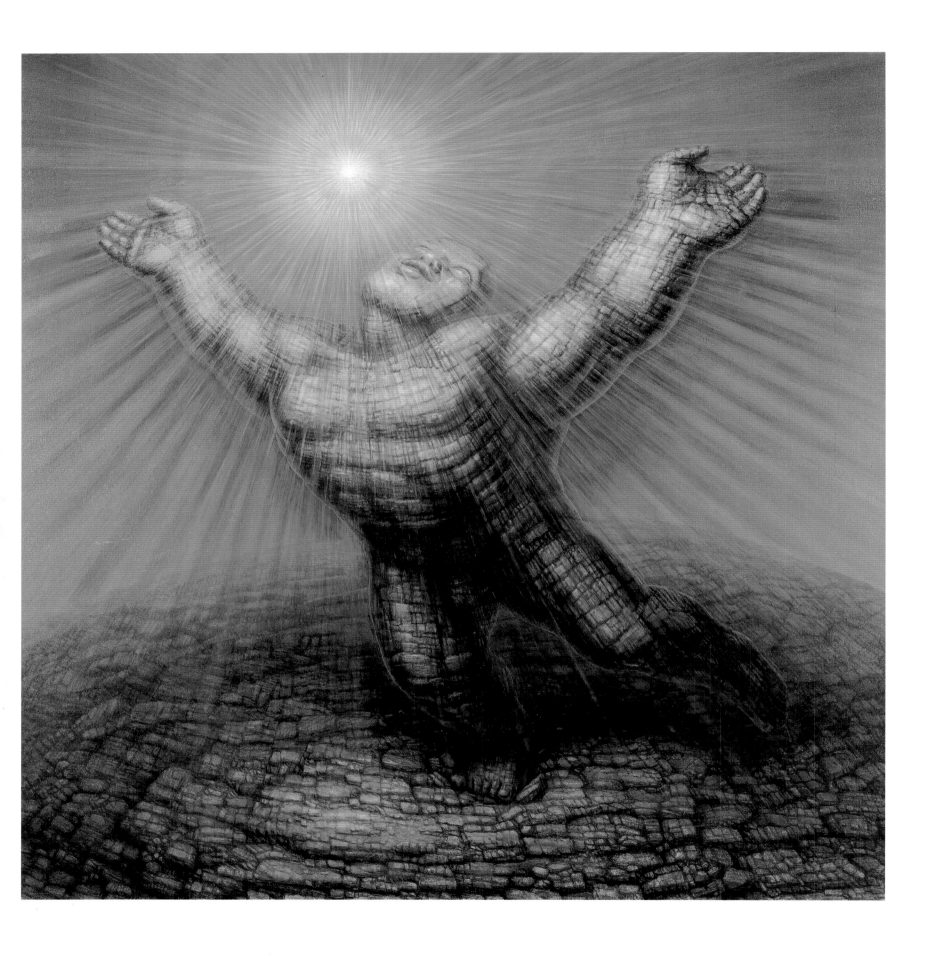

CREATOR'S DANCE

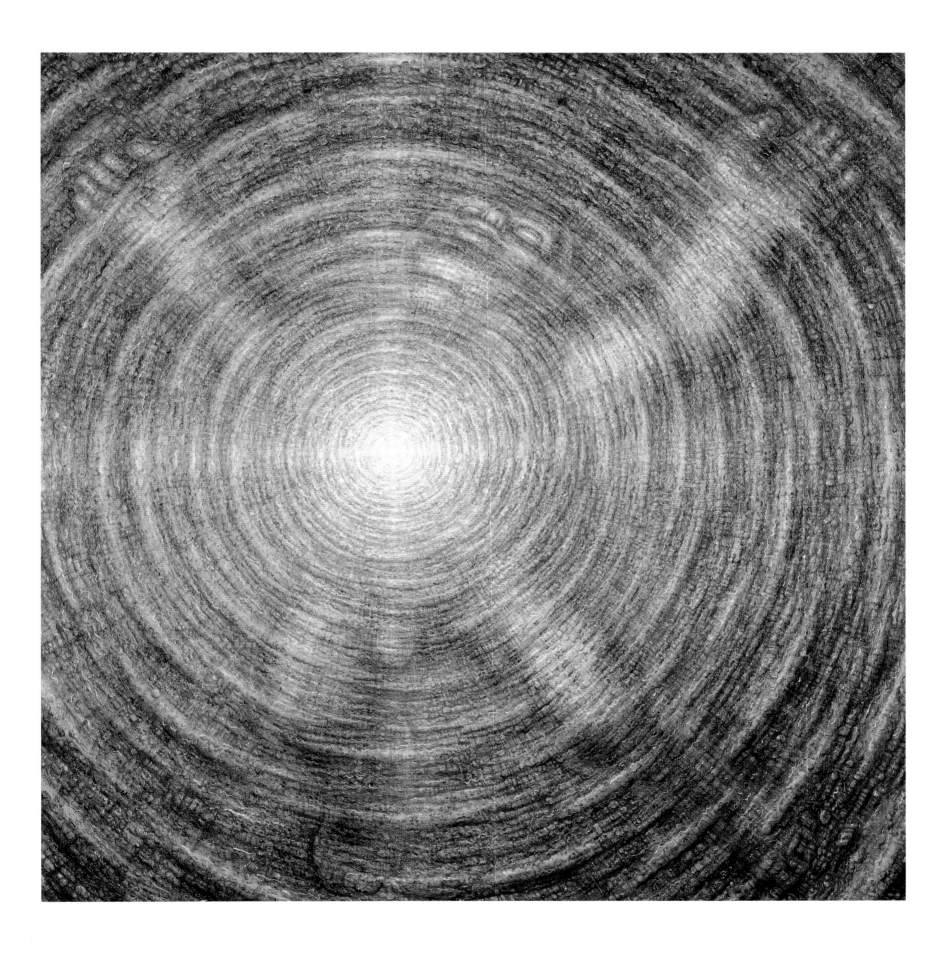

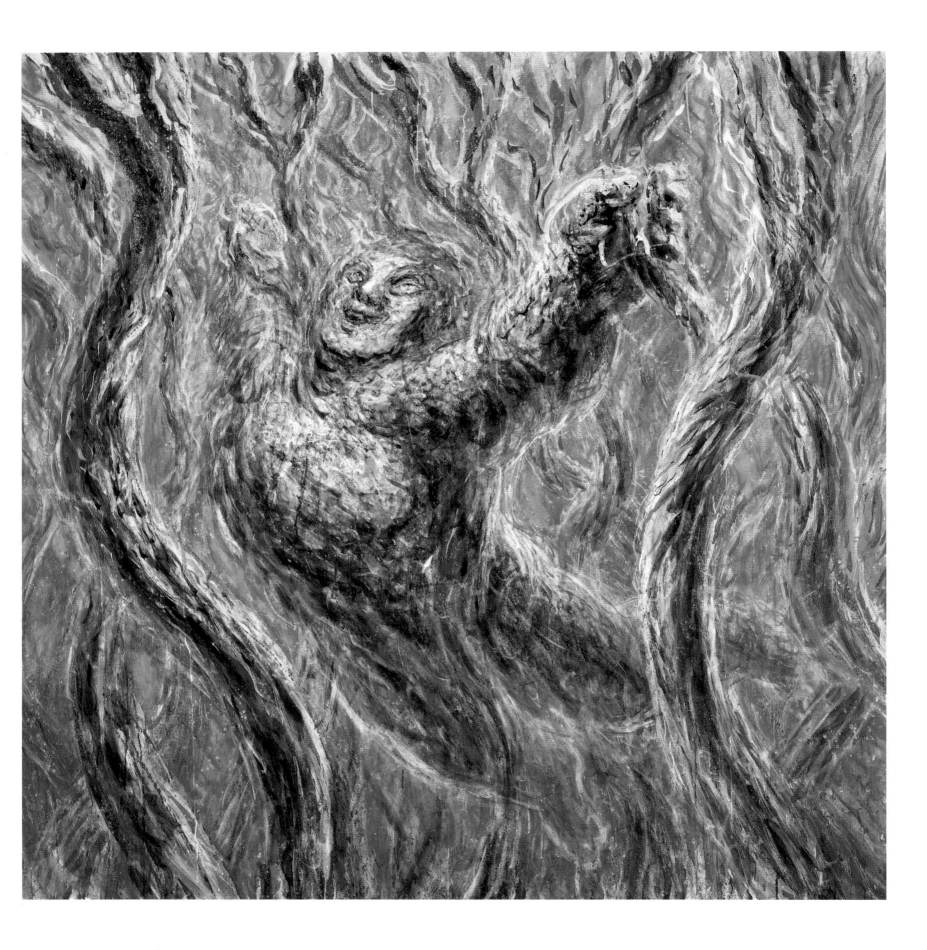

IN HIS ELEMENT

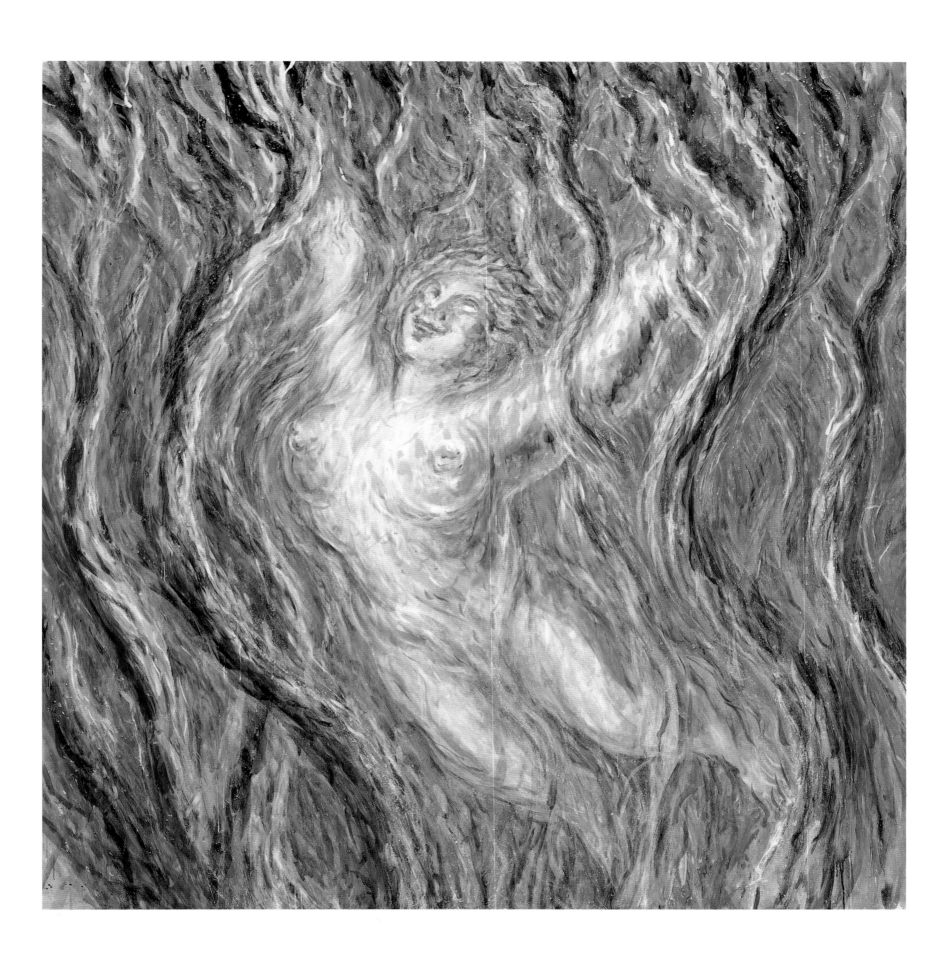

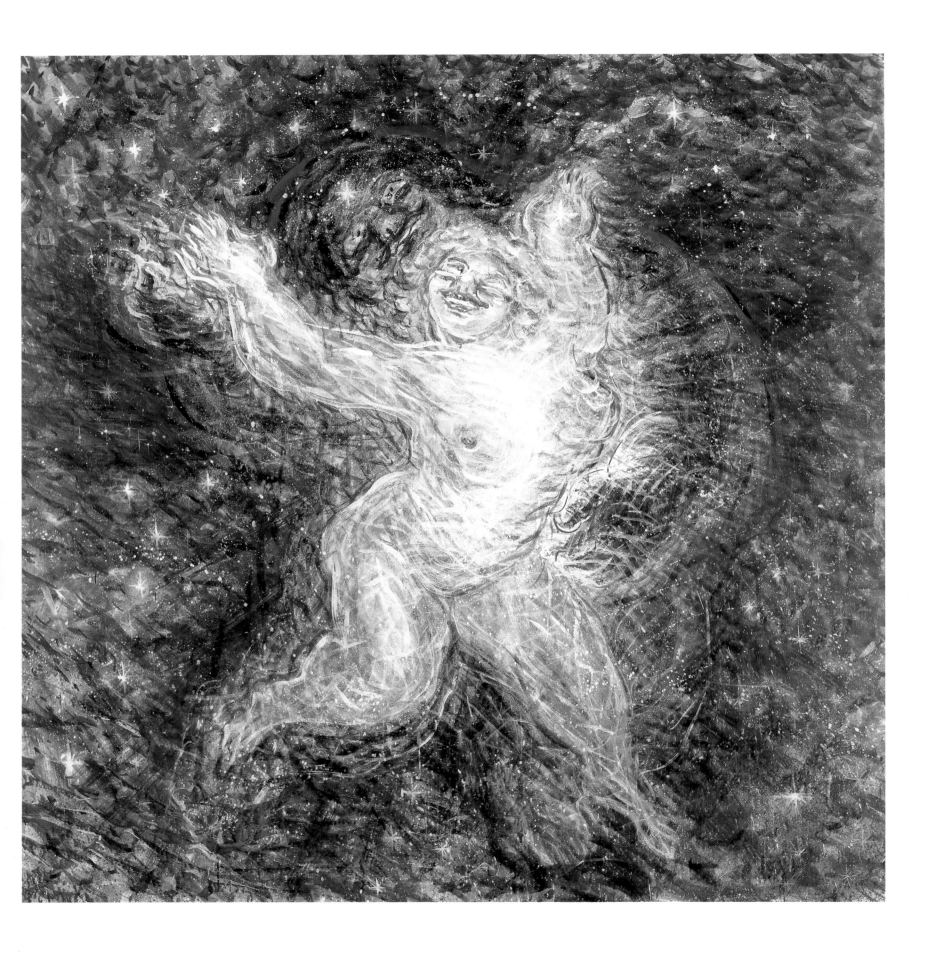

HER DANCE

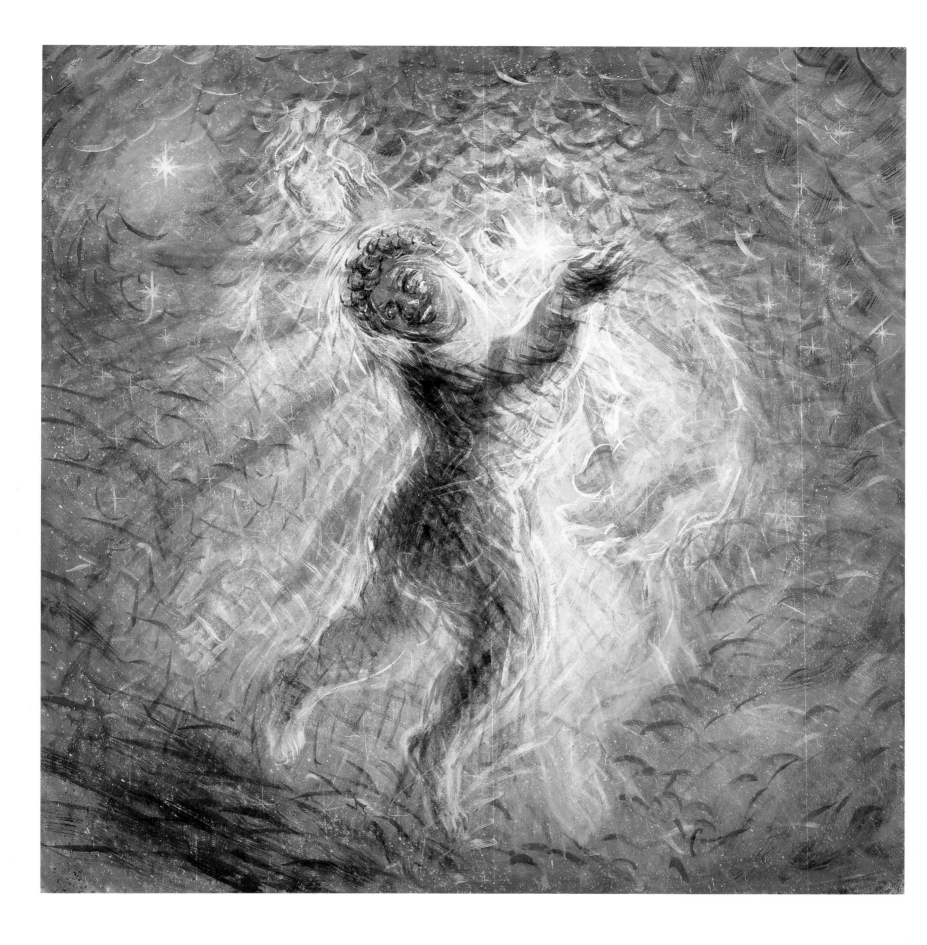

HIS DANCE

Visit to India in 1986

Together with my wife, Marilyn, I met with the Master, Sant Thakar Singh, who connects seekers to God through the natural and ancient path of the "Yoga of the inner light and sound." When he viewed pictures of my work he said, "Art comes from God," and "This is a good way to remind people of the inner light."

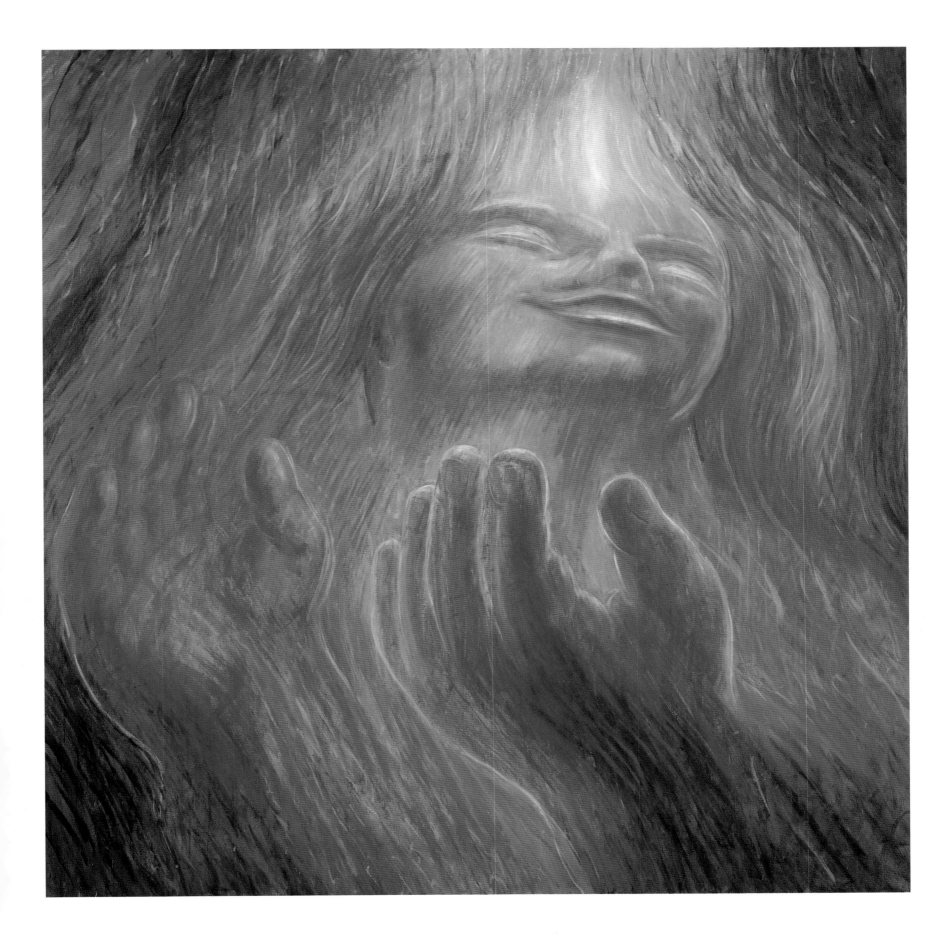

THE FLAME

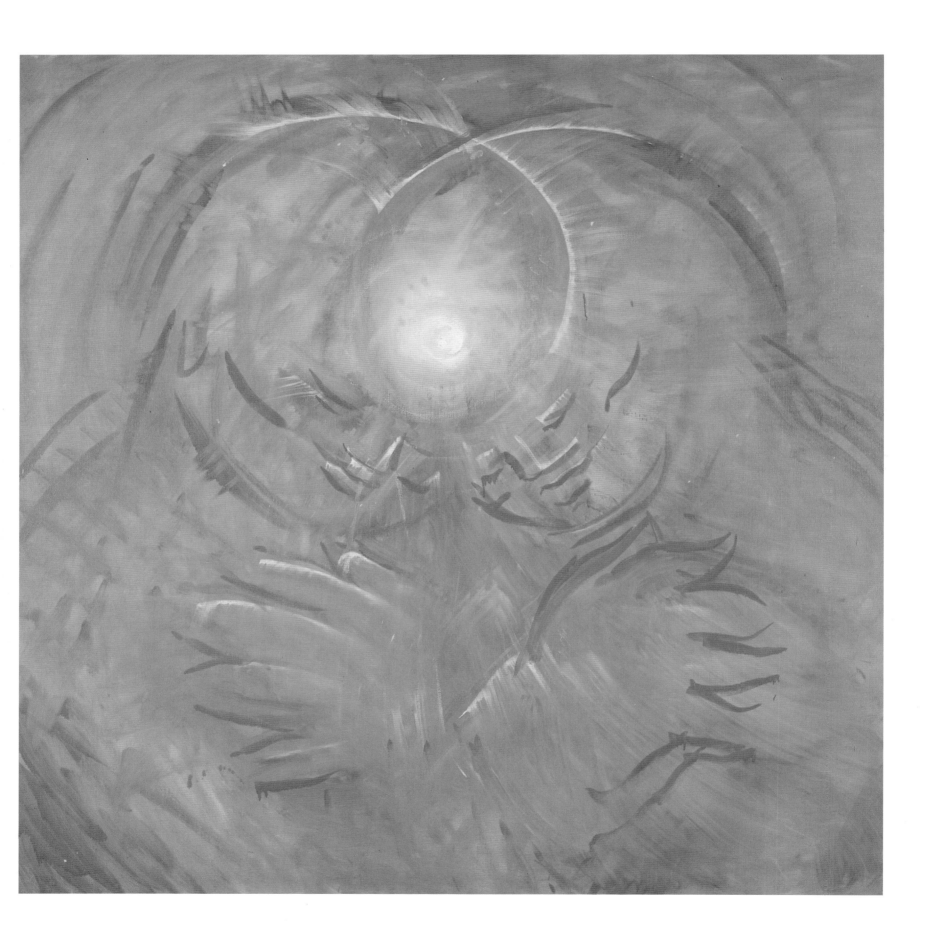

THE ONENESS

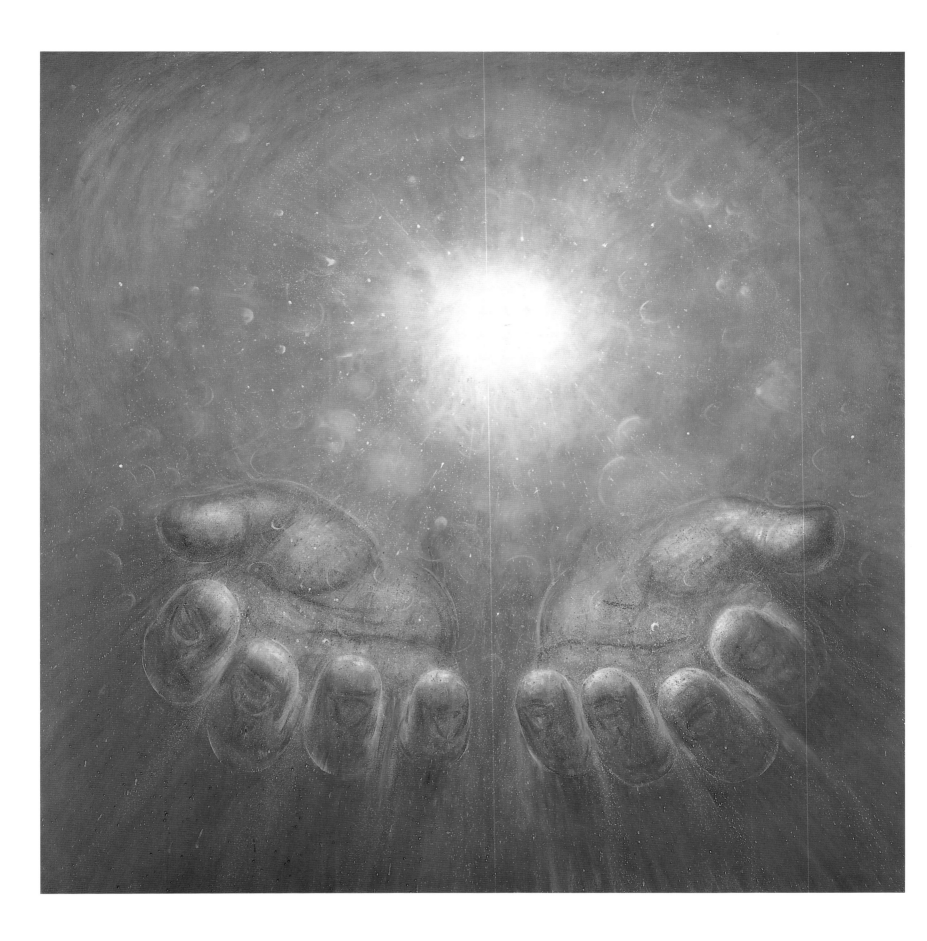

THE GIVING

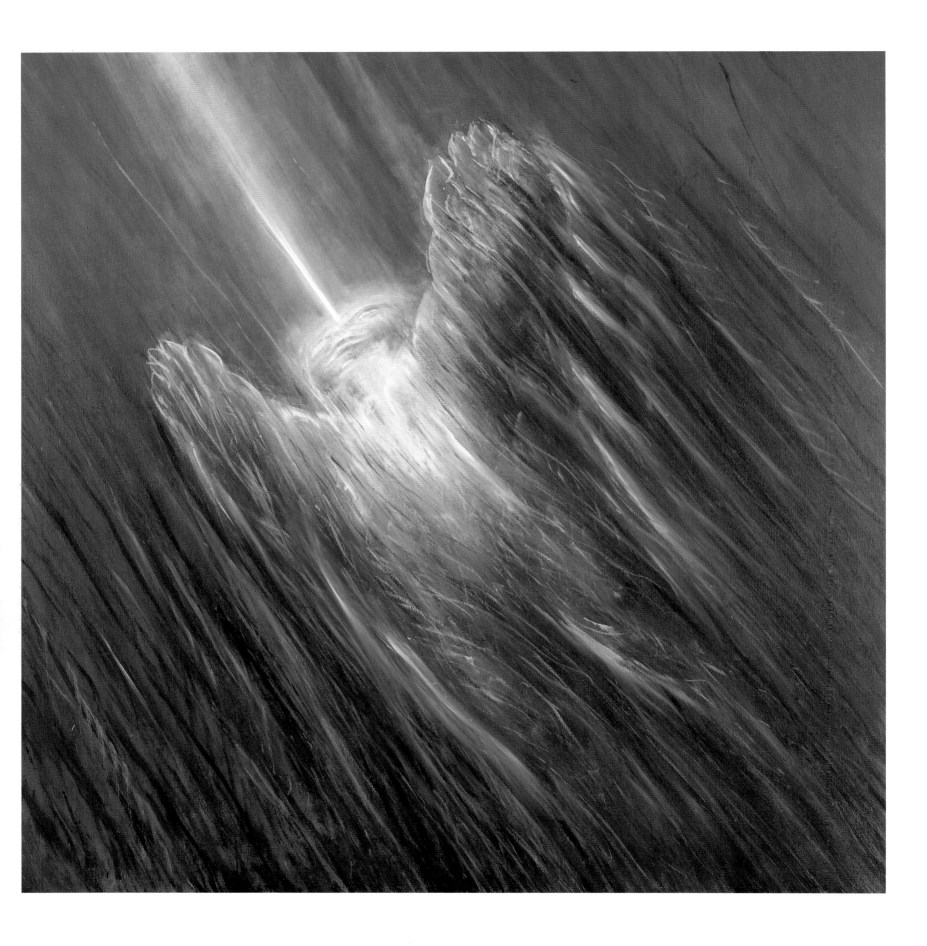

THE CALLING

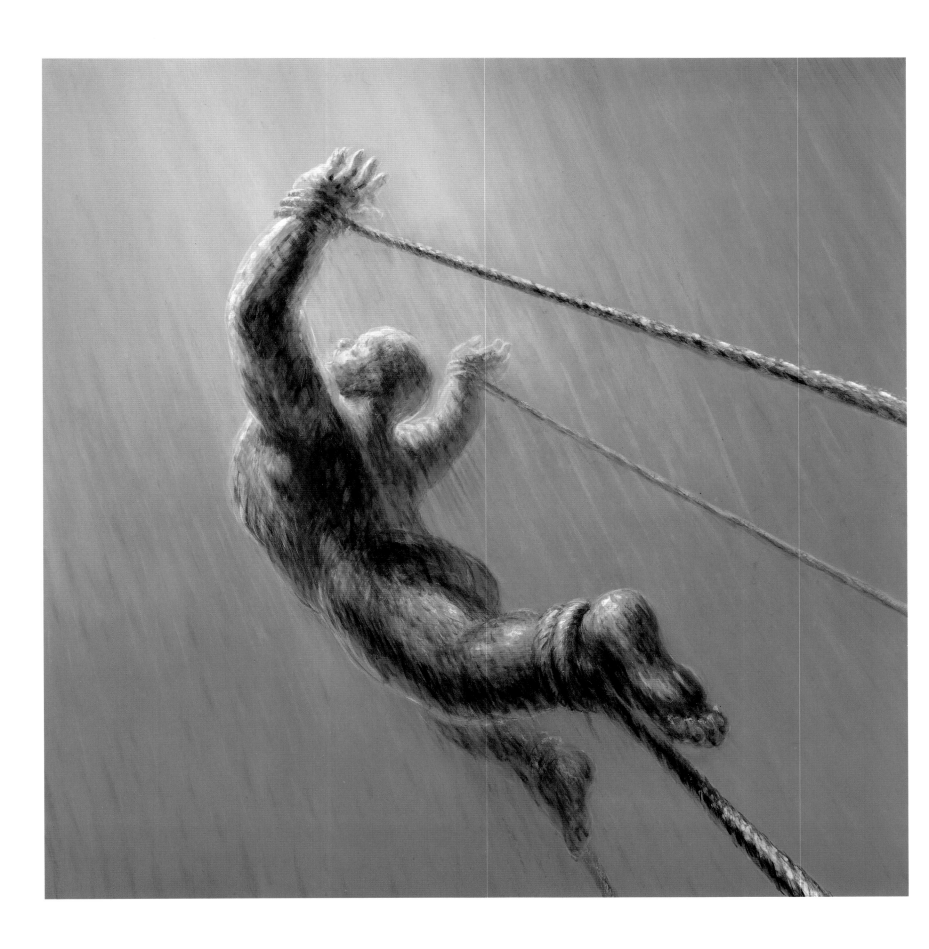

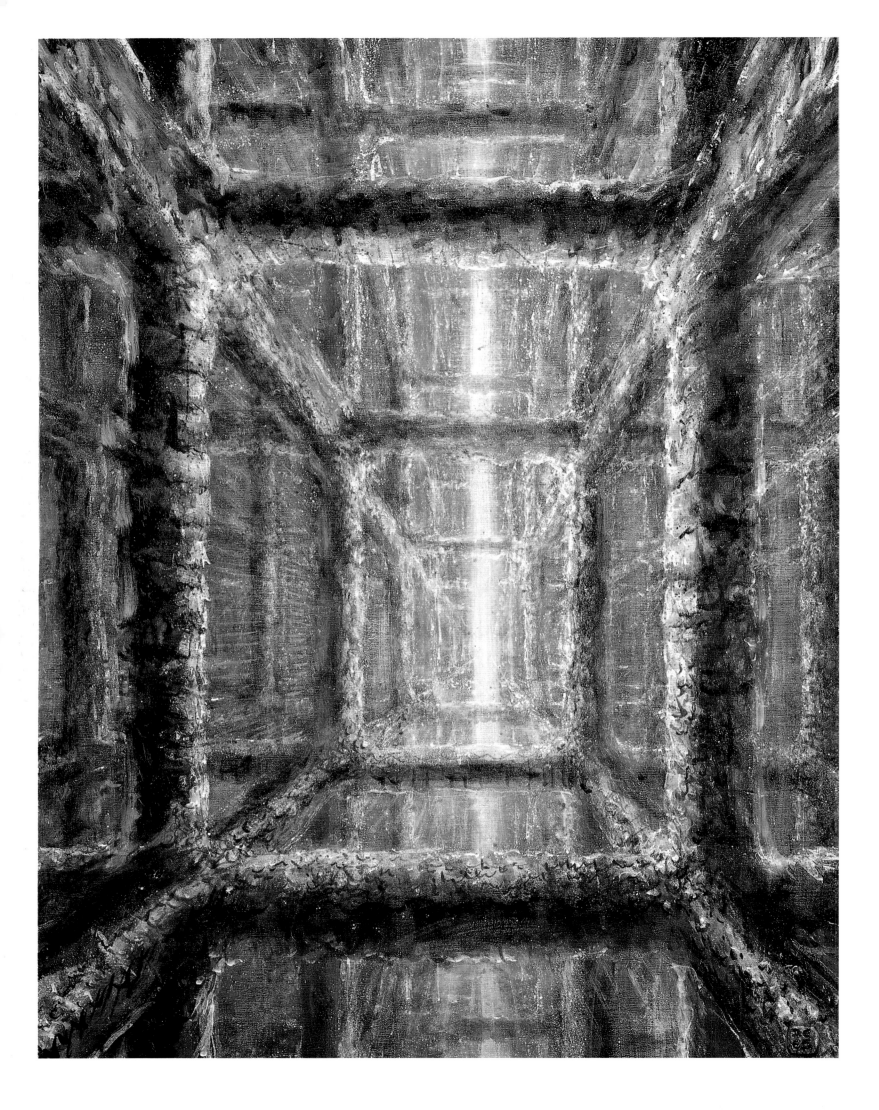

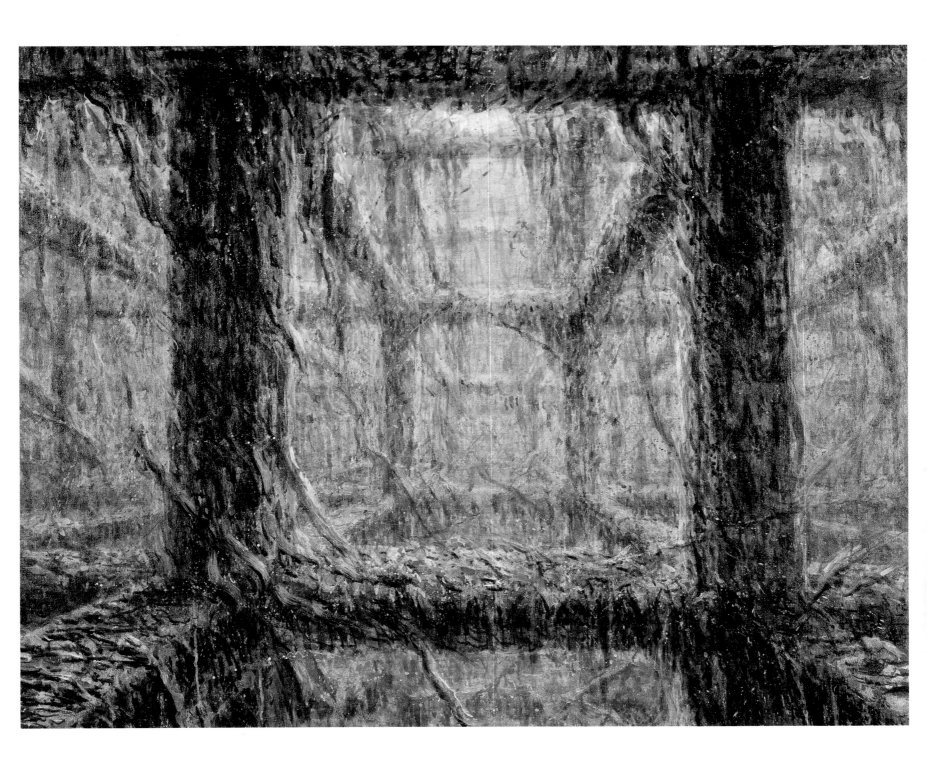

THE LIVING STRUCTURE

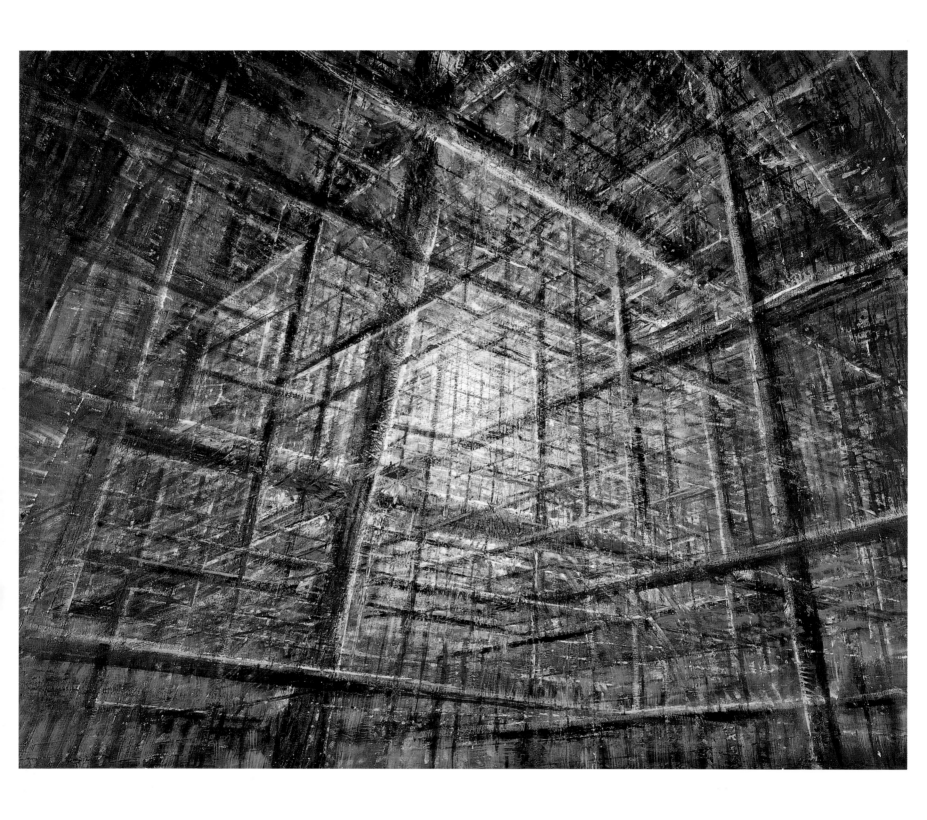

LIGHT CAGE

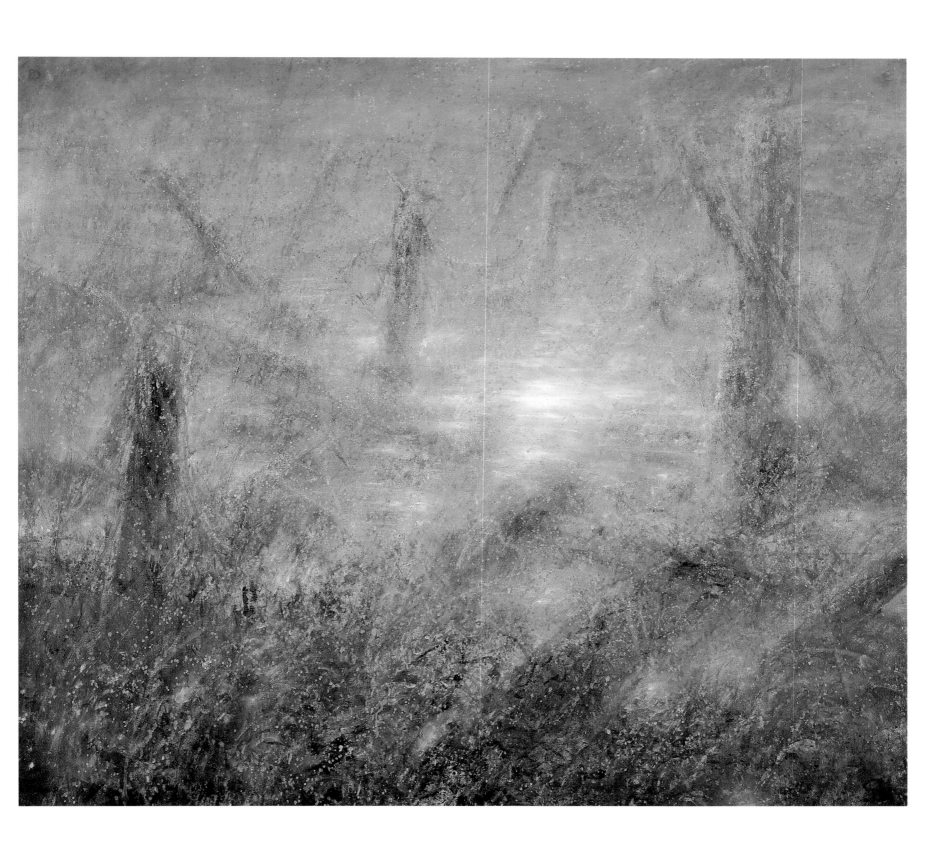

FALLEN STRUCTURE

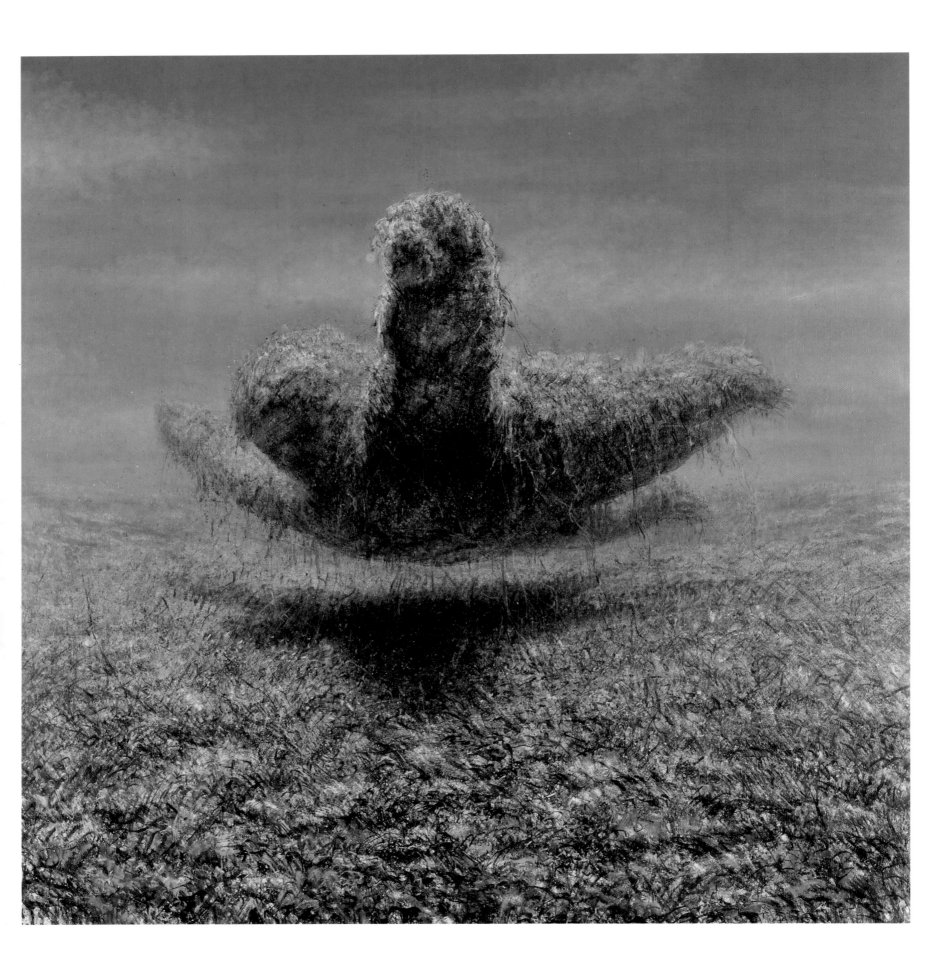

ABOVE THE GROUND

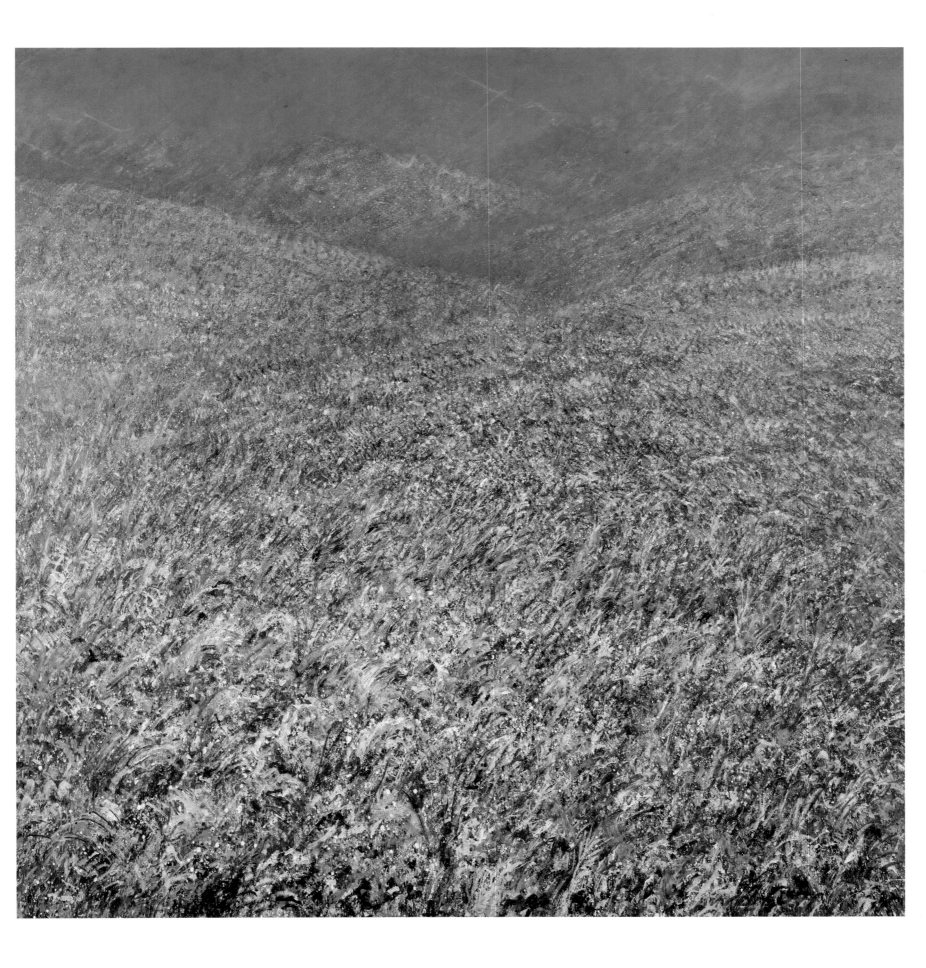

IN THE GROUND

THE BROOK

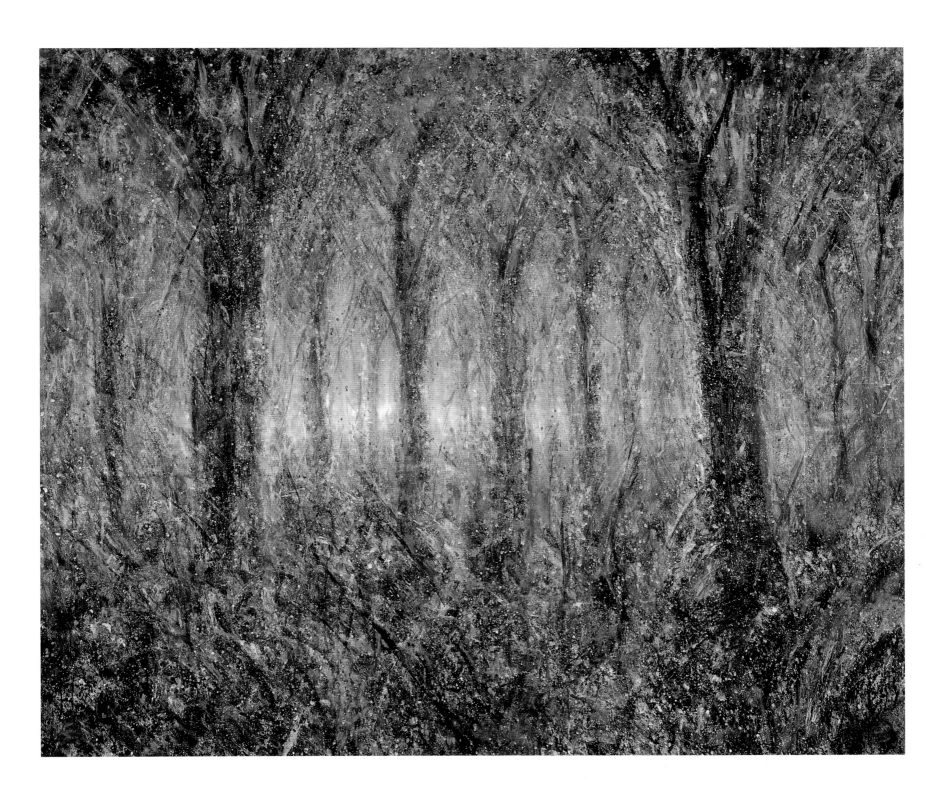

THE CLEARING

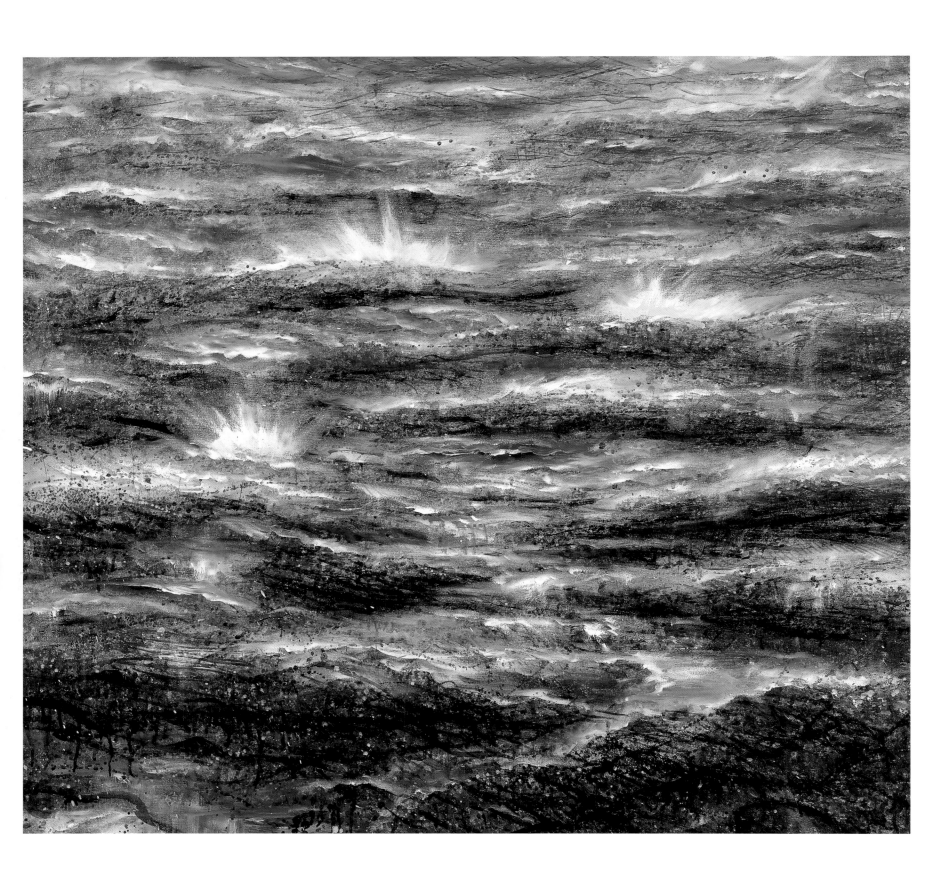

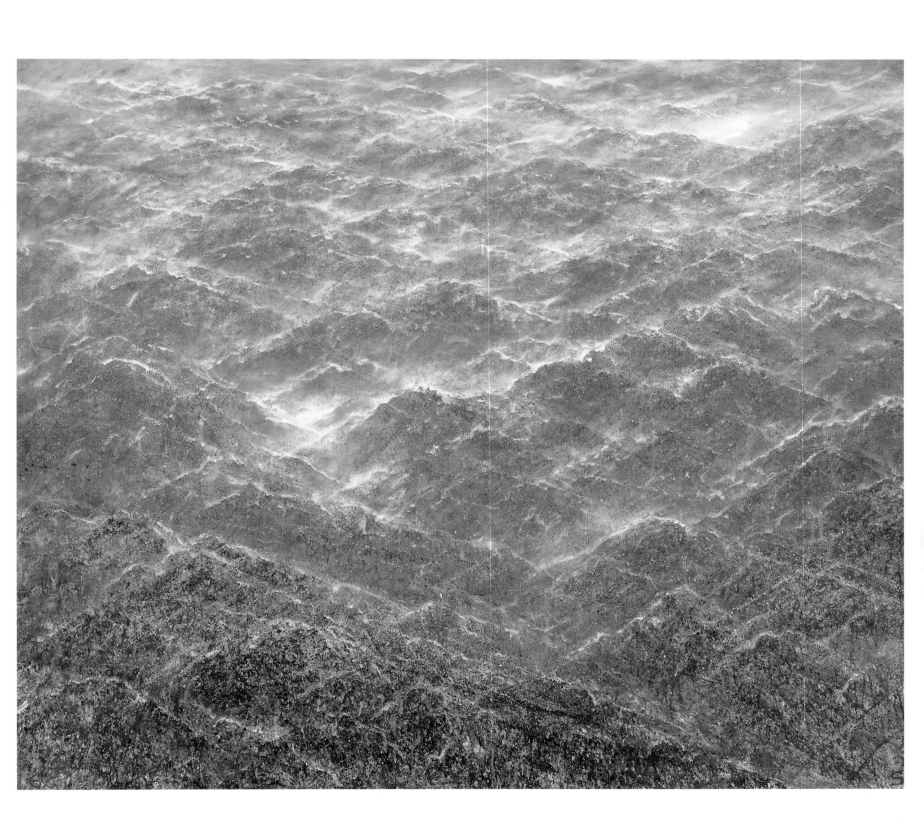

THE PLANETARIANS
Memories of True Magnitude

Painted Sculptures 1987-1991
(Polyester and Acrylic)

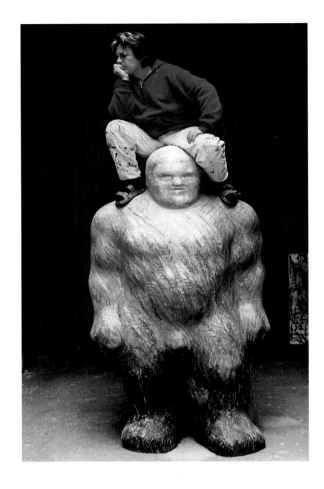

Often, pictures on my stone-paintings have been mistaken for pictures of sculptures. Only after I had moved on from my stone period did I conceive the idea to recreate THE JOINING as a three-dimensional installation. My first sculpture was a small Stoneman. He was constructed of lightweight polyurethane foam and painted like real stone. I then made a large one with the same technique and tried to make multiples by casting it in the same material. However, these casts were not very stable. I went on to make my third sculpture, a mate for "Mr. Basic." Later, the opportunity arose to make forty Stonemen out of a polyester mold for an outdoor exhibition. I quickly became bored with the notion of painting them all in the same stone-like color scheme. I decided to make them all look like completely different entities by painting them in a wide variety of colorful variations, though they would all relate to one another through the logic of the transformative method. I experimented with forty small figures (Earthlinks) and enjoyed the process of painting on a figure rather than a flat canvas. In the end, the grouping demonstrated the unity of a multiplicity of painting styles. The inner core was comprised of monochromes (black, white, yellow or red figures) while the medium ring of Stonemen were done in abstract patterns of varied colors. The outer ring was comprised of more natural colors and designs and blended in with the surrounding environment of the Gurten Weise Park.

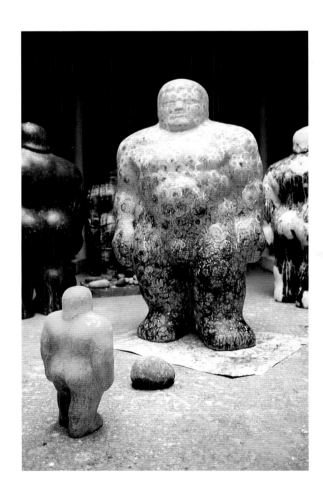

I refer to these variously painted figures cast from the same mold as "Planetarians." They may serve to remind us that we are basically the same as human souls, though we all appear different from each other by putting on unique mental and physical appearances. I enjoy composing different groups of large and small Planetarians, such as a figure painted in a forest scheme standing before a forest painting.

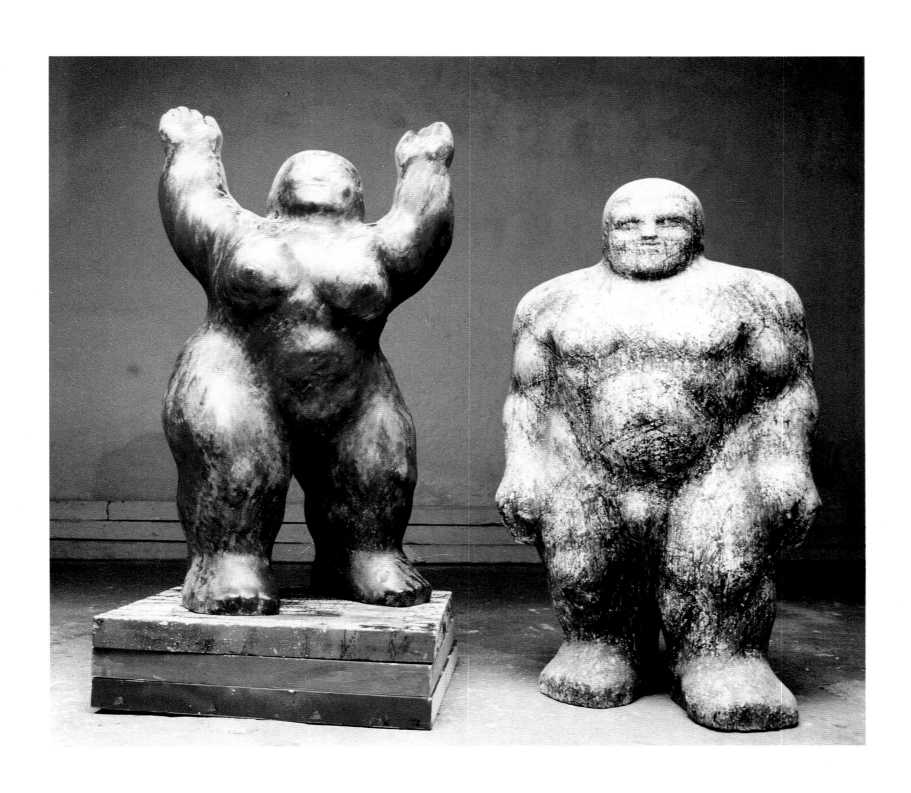

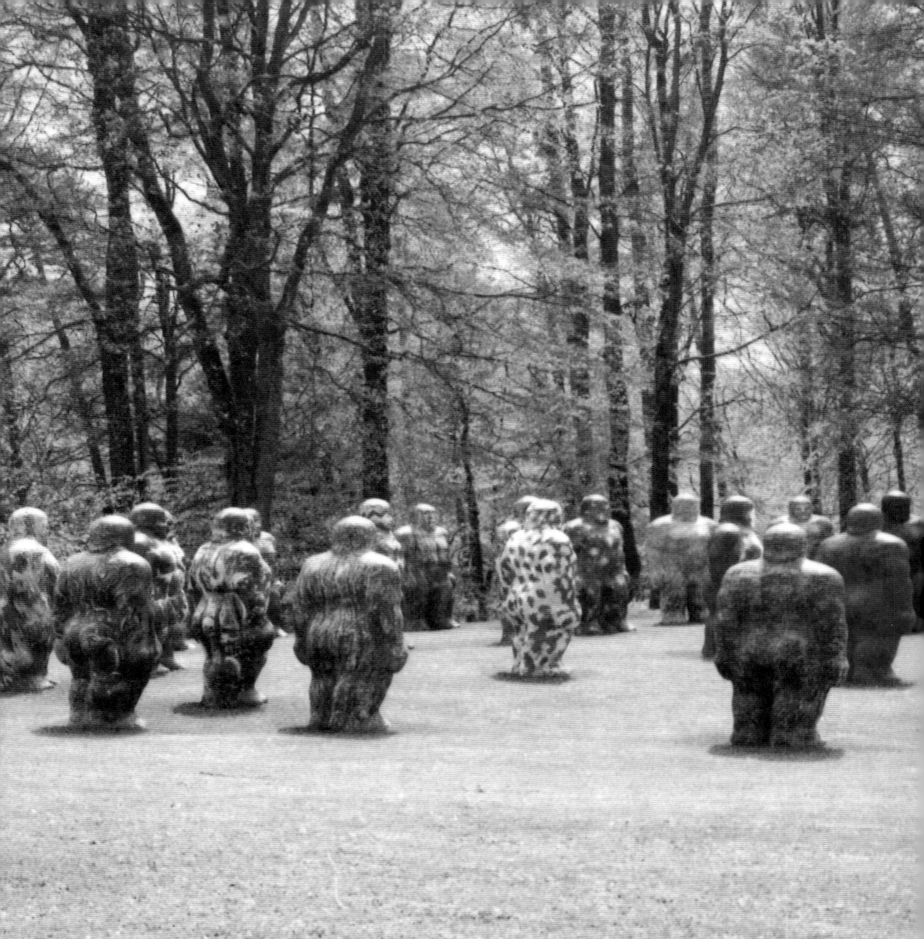

THE GATHERING

Outdoor exhibition of a grouping of forty planetarians (each one about six feet in height) assembled on the Gurten Mountain in Bern Switzerland

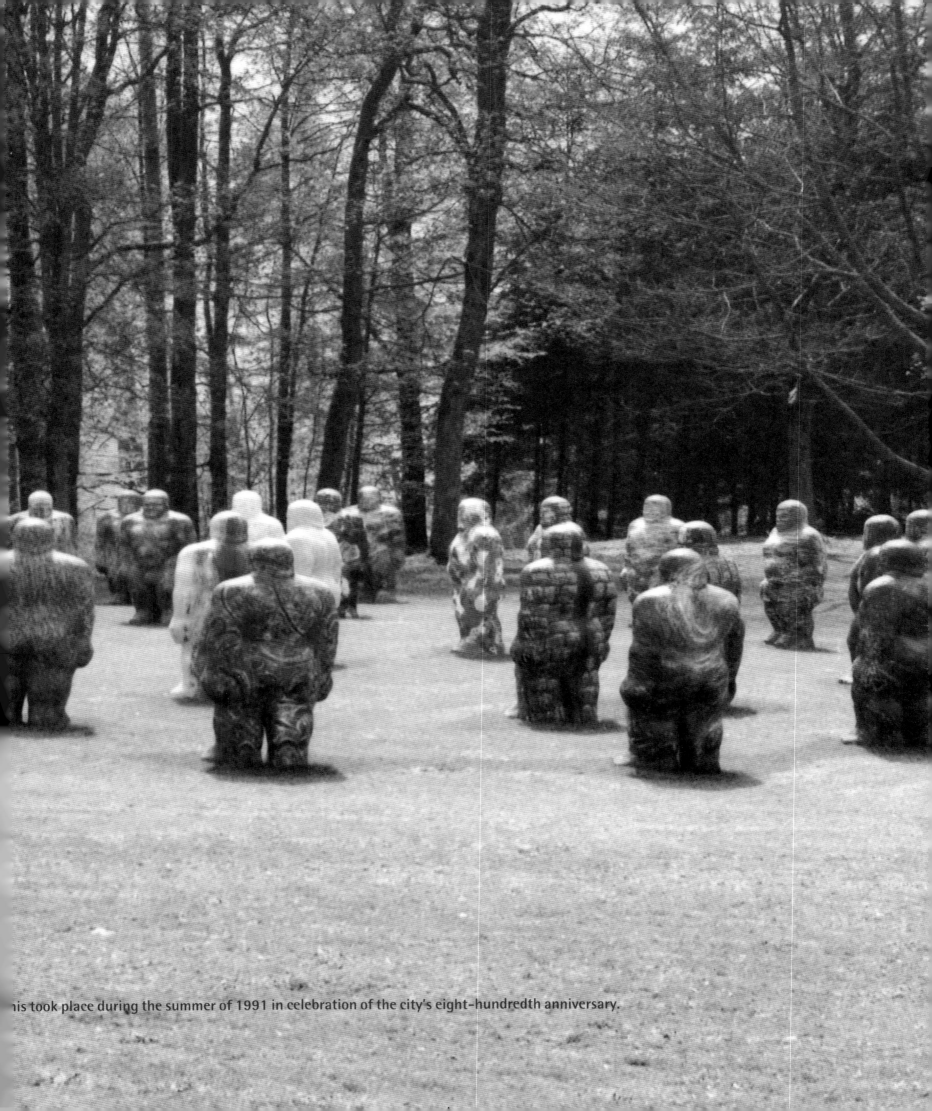

...his took place during the summer of 1991 in celebration of the city's eight-hundredth anniversary.

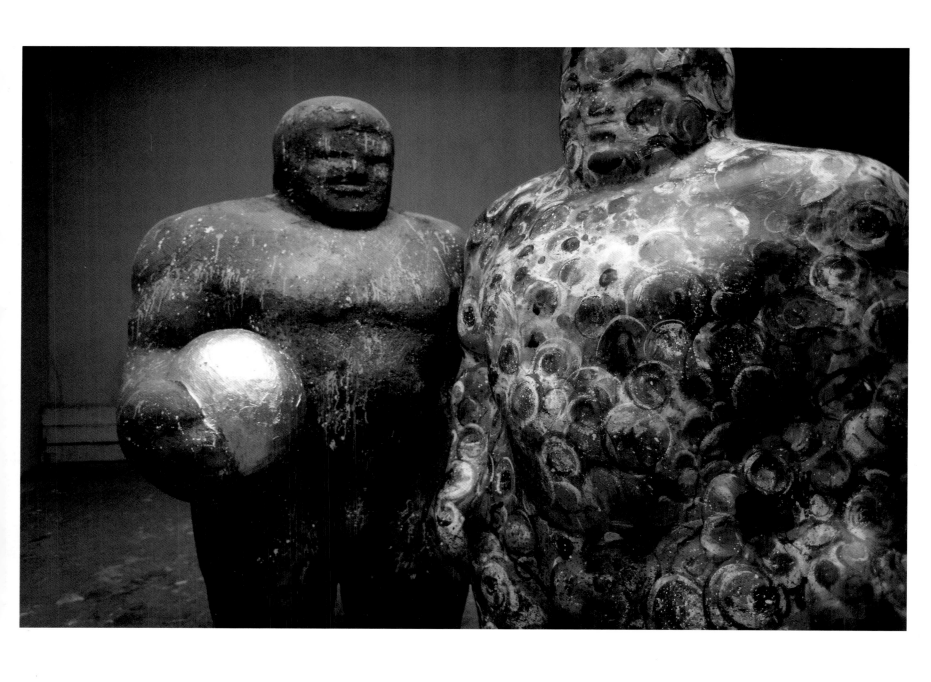

THE SUNBALL PLANETARIAN

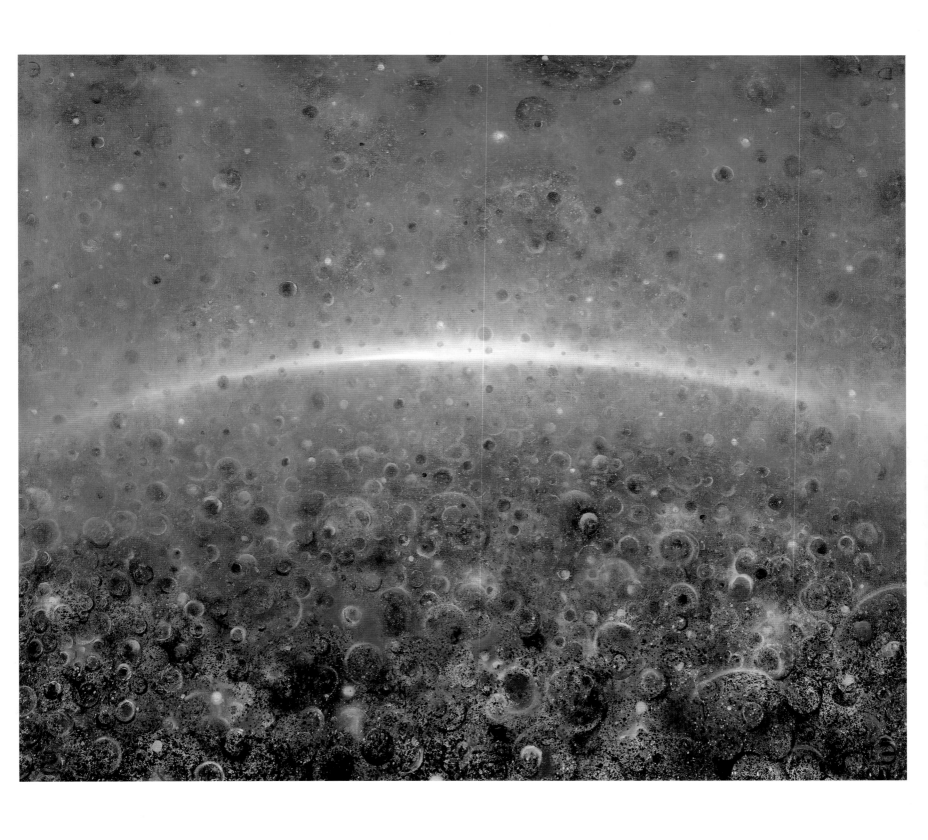

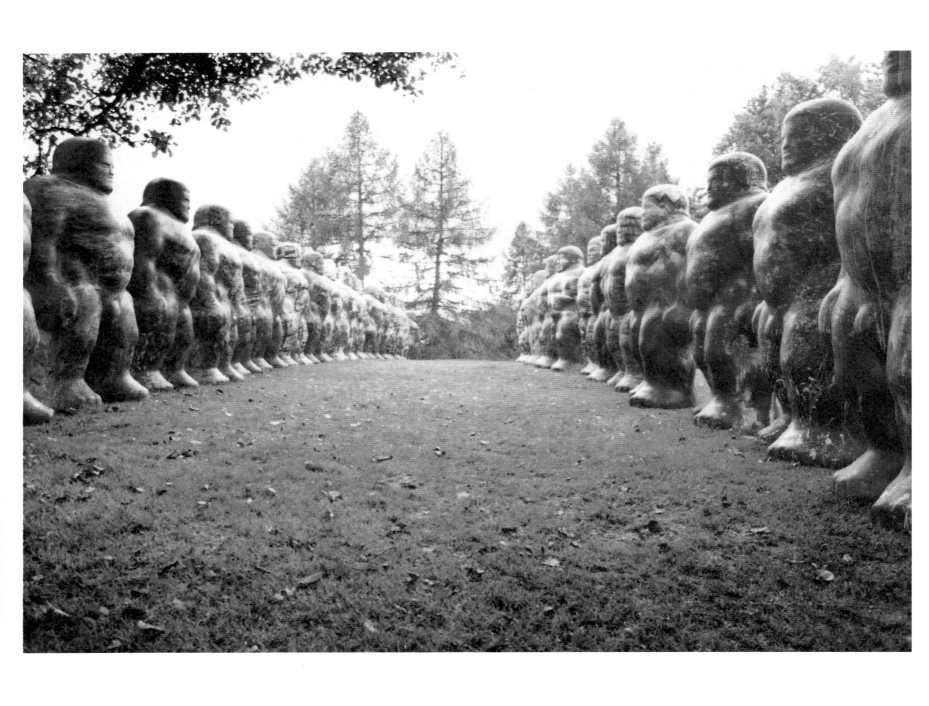

STREET OF THE PLANETARIANS
Gurten Mountain, Bern 1991

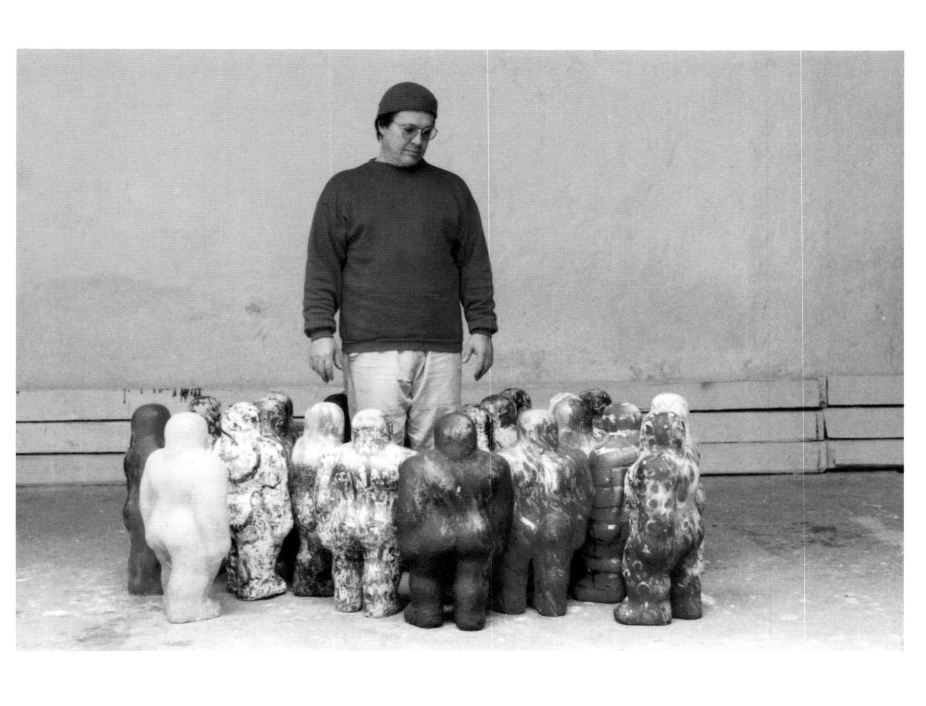

De Es in 1990 with Earthlinks.

PAINTINGS:

*Dome of Peace Entrance **Dome of Peace

PUBLISHED IN:

OMNI MAGAZINE

HEAVY METAL MAGAZINE

TRIAD MAGAZINE

AVANT GARDE MAGAZINE

BRES MAGAZINE

ARTS MAGAZINE

L'ART VISIONAIRE (By Michael Random)

THE VIENNESE SCHOOL OF FANTASTIC REALISM (By J. Muschik)

ONE-MAN EXHIBITIONS AND GROUP SHOWS:

1963: Galerie Ernst Fuchs in Vienna, Austria

1965: Galerie Ernst Fuchs in Vienna, Austria

1970: Galerie Bernard in Solothurn, Switzerland

Galerie Aurora in Geneva, Switzerland

Galerie Hartmann in Munich, Germany

1971: Aktions Galerie in Bern, Switzerland with H.R. Giger

Galerie Palette in Zürich, Switzerland

Galerie Herzog in Büren, Switzerland

1972: Aktions Galerie in Bern, Switzerland

1973: Galeria La Lanterna in Trieste, Italy

1974: Künstlerhaus Galerie in Vienna, Austria

Galerie Spektrum in Vienna

Galerie Akademia in Salzburg, Austria

Galerie Jasa in Munich, Germany

Center of Art and Communication in Vienna, Austria

1975: Hansen Gallery in New York City

1976: James Yu Gallery in New York City

Aldrich Museum in Connecticut

1977: Graham Gallery in New York City

1978: Gallery Yolanda in Chicago

1979: Hansen Gallery in New York City

Quantum Gallery in New York City

1980: Hansen Gallery in New York City

Virtu Gallery in Naples, Florida

Bronx Museum in New York

1981: Art Expo New York

Marshall Fields Gallery in Chicago

Govinda Gallery in Washington, D.C.

1982: Art Expo New York

Graham Gallery in New York City "New York Visionaries"

1983: Museum of the Visual Arts in New York

1984: Austrian Artists at IMF in Washington D.C.

1980-86: Studio Planet Earth in New York City

1987: Galerie Würthle in the "Sinnreich"

1988: Galerie Steinmühle near Linz, Austria

Sammlung Ludwig Neue Galerie in Aachen, Germany

1990: Opel Fine Art in Vienna, Austria

1991: Gathering of Forty Planetarians in Bern, Switzerland sponsored by the Loeb Corporation.